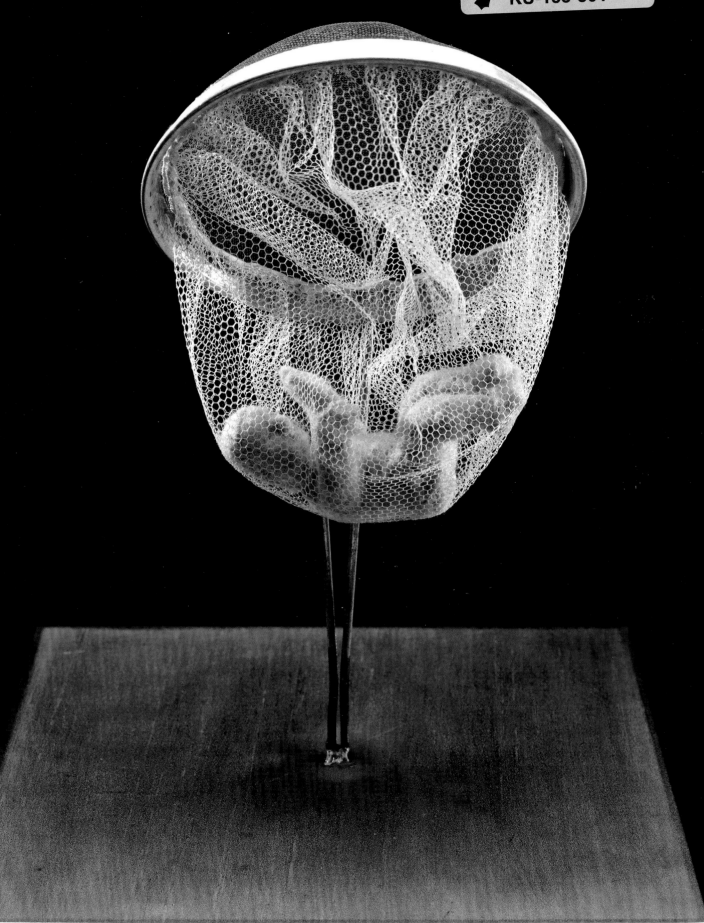

MODERN ARTISTS

First published 2010 by order of the Tate Trustees
by Tate Publishing, a division of Tate Enterprises Ltd,
Millbank, London SW1P 4RG
www.tate.org.uk/publishing
© Tate 2010

The moral rights of the author have been asserted.
A catalogue record for this book is available from the
British Library
ISBN 978 1 85437 882 8
Distributed in the United States and Canada by
Harry N. Abrams, Inc., New York
Library of Congress Control Number: 2010924786
Designed by Mr & Mrs Smith
Colour reproduction by Alta Image, London
Printed and bound in Singapore by C S Graphics

Front cover (detail) and previous page:
THE WOVEN CHILD 2002
Fabric, steel and aluminium 23.5 x 20.3 x 20.3

Overleaf: SPIDER 2003
Steel and tapestry 45.5 x 59.9 x 64.7
Collection Carolee and Nathan Reiber

Author's acknowledgements

It has been a privilege to write about Louise Bourgeois's
extraordinarily inspiring life and work. I feel extremely lucky
to have been able to consult the artist when writing this
book during the last year of her life.

This publication would not have been possible without the
collaboration of Jerry Gorovoy and Wendy Williams. Thanks
are due to them, and to Frances Morris and Lewis Biggs for
their input and support. Thank you to Rebecca Fortey,
Judith Severne, Beth Thomas and all at Tate Publishing who
have helped to make the book a reality. I am also grateful
to Silke Klinnert for her intelligent design.

Thanks to Cliff for patience, understanding and helpful
comments, and to Mando for insight.

This book is for MC.

Ann Coxon

Tate Publishing

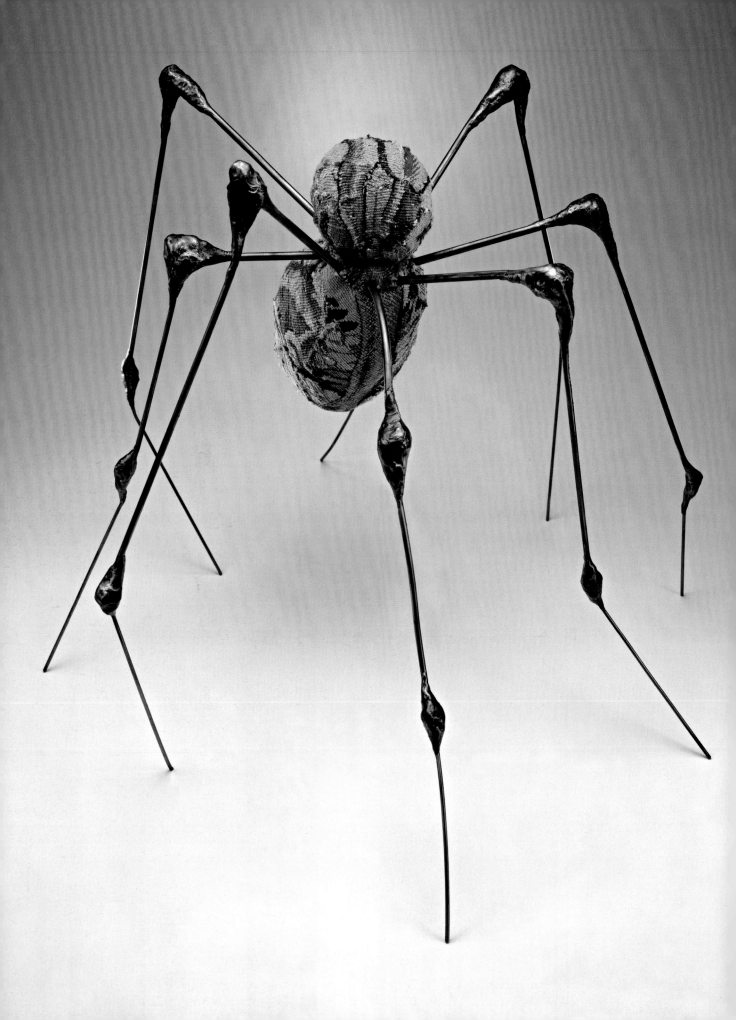

MAMAN 1999 [1]
Bronze, stainless steel and marble
927.1 x 891.5 x 1023.6
National Gallery of Canada, Ottawa

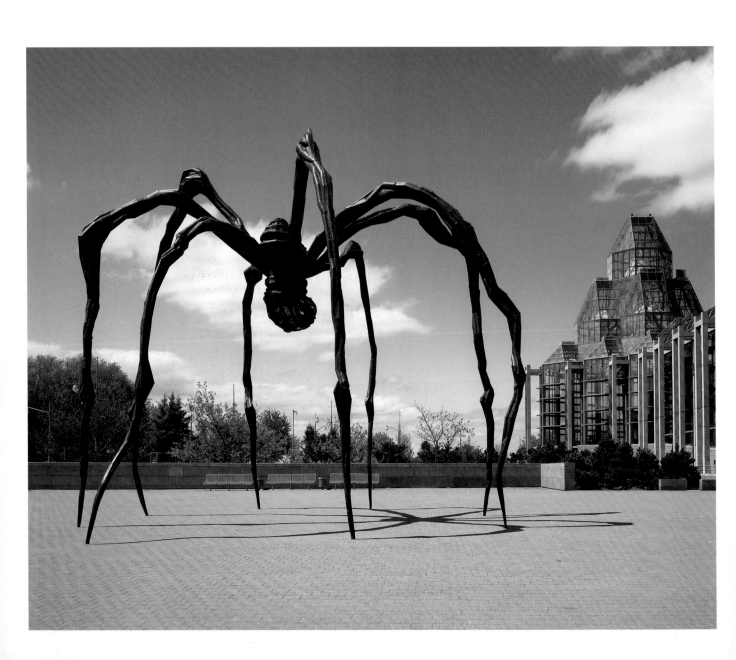

Robert Mapplethorpe
LOUISE BOURGEOIS, 1982 [2]
Gelatin silver print 50 x 40.6
Photo © 1982 The Robert
Mapplethorpe Foundation

INTRODUCTION

Those who know little else about Louise Bourgeois will perhaps associate her name with the looming, nine-metre-high spiders that they may have seen on their travels. Visitors to the National Gallery of Canada, Ottawa, The Guggenheim Museum, Bilbao, the Roppongi Hills complex of the Mori Art Museum in Tokyo, or the Leeum Samsung Museum of Art in Seoul will not have failed to notice (and may even have had their picture taken beside) Bourgeois's most famous sculpture, *Maman* 1999, produced in bronze in an edition of six (fig.1). The original steel version was shown as part of Bourgeois's installation in the cavernous Turbine Hall at Tate Modern in London for the museum's opening in the year 2000, marking her out as one of the most important artists of the twentieth century. In the first decade of the twenty-first century, though in her nineties, she continued to make significant works and her major retrospective exhibition toured to five venues in Europe and the United States. In 2008 President Sarkozy visited her home in New York in order to present her with the medal for the French Legion of Honour. Bourgeois collaborated in the process of creating this book before her death in May 2010.

Like many women artists who reach a certain level of success, Bourgeois became a famous face. She was often photographed alongside her sculptures, and those who wish to find out more about the creator of *Maman* will soon stumble upon pictures of this small French woman reproduced in the exhibition catalogues, monographs, academic journals, interviews, television programmes, films, press articles and reviews that have taken her life and work as their subject. A remarkable portrait by controversial photographer Robert Mapplethorpe (fig.2) shows Bourgeois in her early seventies, the lines on her face helping to exaggerate her worldly-wise expression and cheeky grin. She is wearing a black monkey-fur jacket and cradling under her right arm her most blatantly phallic latex sculpture, *Fillette* 1968. This image helped to solidify Bourgeois's persona as a 'bad enough mother' for the art world (a term used and explored by art-historian Mignon Nixon in her 1995 feminist, psychoanalytic reading of Bourgeois's work).[1] The picture was printed in the catalogue for Bourgeois's first major retrospective at the Museum of Modern Art in New York in 1982, though the bottom half of the image was cropped, leaving the reader unaware of the reason for her sardonic smile.

It was at the time of this exhibition that Bourgeois also revealed, in a slide show and magazine project, the images and recollections of her childhood that have since become the reference points for much of the psycho-biographic writing about her. Pictures from her family albums illustrate the story of her upbringing in France, the large family residences at Choisy-le-Roi (fig.3) and Antony, and the tapestry-restoration workshop and gallery run by her parents (fig.4). Soon to follow are pictures of Sadie Gordon Richmond (fig.5), the young English tutor who was hired in 1922 to teach English to the Bourgeois children. Sadie was relatively close to Louise in age and had been much liked by her until it was discovered that she was having an affair with the father, Louis Bourgeois, whilst living in the family home – a double betrayal to the young Louise. Bourgeois's commentary runs alongside the photographs. She once stated: 'The motivation for the work is a negative reaction against her [Sadie]...it is really the anger that makes me work.'[2]

Bourgeois's writings and statements feature strongly in the publications about her life and her work. Extracts from diaries, interviews, written statements and other sources set out her ideas and motivations in a highly self-analytical manner. Taken

Louise Bourgeois in profile on her
mother's lap, in front of the family
house, Choisy-le-Roi, c.1914 [3]

Louis Bourgeois in the tapestry
gallery Maison Louise Bourgeois
at 174 boulevard Saint-Germain
in Paris, c.1916 [4]

out of time and context her assertions can be contradictory, and indeed, as Bourgeois herself said in a statement first published in 1954: 'An artist's words are always to be taken cautiously. The finished work is often a stranger to, and sometimes very much at odds with what the artist felt or wished to express when he began.'[3] Nevertheless, Bourgeois's words were usually carefully chosen and in the verbal, as well as the visual, she had a talent for putting her finger on it, for pinning down passing thoughts and ideas. It is easy to see why certain of her sentences have been referenced and repeated many times, since they often provide the key to our understanding of her complex and varied artworks.

Though selected photographs, biographical facts and quotations will be present throughout, this book sets out to address the body of work produced by Bourgeois, not her life-story. It will introduce her prolific output as an artist working for over seven decades, and will consider the evolution of her ideas, methods and materials. Bourgeois was able to reinvent her practice, experimenting with new materials, techniques and methods of presentation to move with the times, and this is one of the reasons why she was, perhaps uniquely, seen as a 'contemporary' artist throughout her lifetime. In addition, she was a life-long diarist, recording her thoughts in drawn or written form in notebooks, on paper or on whatever surface or material comes to hand. Many of her themes recur over the years and this – coupled with Bourgeois's own denial of particular artistic allegiances – has led curators, critics and writers to conclude that her work should not be labelled or interpreted according to one particular time, moment or movement in the recent history of art. However, it is possible and important to look at the different stages of her practice in relation to the historical and physical circumstances in which

they were made. So often with Bourgeois there is a delay between the work's creation and its public understanding and reception. Following a roughly chronological structure, the chapters that follow will therefore focus on the evolution of her techniques, methods, materials and strategies, putting her choices into context. Bourgeois's selection of materials and the way in which they are worked is inextricably linked to her understanding of certain psychological states. Looking at the materiality of her work is therefore vital to any consideration of its meaning. However, this is only one way of telling the story of her work – it would be equally possible to look at specific subjects and repeated themes. Following each chapter, a key work from the relevant period of Bourgeois's career will be considered in depth, including quotations from the artist. These sections also draw out some of her most important themes and ideas. The final chapter will take the form of an essay looking at the representation of pregnancy in Bourgeois's work.

For Bourgeois, destruction is a necessary part of the creative process. The anger that fed her work is legendary (film footage shows her smashing pots or spitting venom at various interviewers), but so were her strength and generosity. In her late nineties, she held 'Sunday salons' in the house where she lived for over forty-five years, creating opportunities for young artists to meet her and to discuss their work. She had not left the house for some years, but remained open to new influences, though her energy was not what it used to be. And she still made work. Bourgeois's love of making was tangible. Over the years, she may have been driven by a need to create as a way of silencing her demons, of recording her past, of telling stories, of channelling her emotions, of calming her anxieties, of exploring materials, or of refining her vocabulary of sculptural forms; but whatever her motivation, it is

Sadie Gordon Richmond, the
mistress of Louise Bourgeois's
father Louis, 1924 [5]

clear that the daily discipline of making (which over
her lifetime included painting, writing, drawing,
cutting, sewing, sketching, carving, assembling,
gathering, collecting, etc) was one that kept her going.
A long-standing friend of Bourgeois, curator and
professor Robert Storr stated his belief that 'the role of
representation and narrative in her work has always
been subordinate to the primary and ceaseless activity
of making and unmaking and remaking'.[4] And as the
artist herself said: 'I need to make things. The physical
interaction with the medium has a curative effect. I
need the physical acting out. I need to have these
objects exist in relationship to my body.'[5]

This long lifetime of creating has resulted in a
wealth of fascinating, powerful and varied artworks
– far too many to be considered individually here –
that add up to a hugely important contribution to the
history of twentieth- and twenty-first-century art.
Bourgeois has been an inspiration to generations of
artists and makers. In a culture obsessed with youth
and novelty, she has forced us to reconsider the idea
of a 'life's work'. Her impressive creative output is
her legacy, towering over us like *Maman* now that
she has gone.

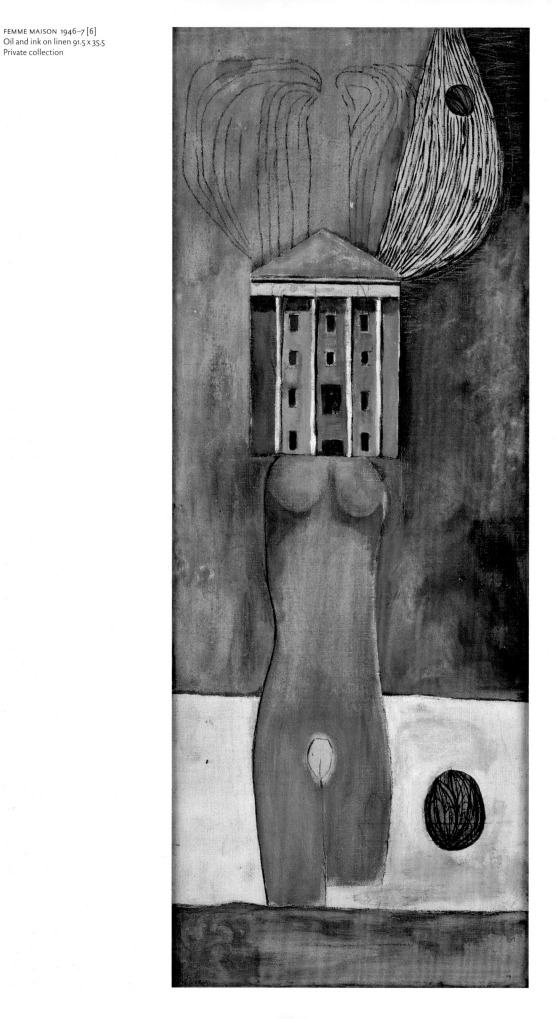

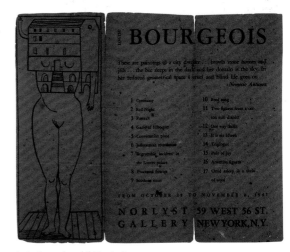

FEMME MAISON 1946–7 [7]
Ink on linen 91.5 x 35.5
Collection of Ella M. Foshay

Invitation to the exhibition *Louise
Bourgeois: Paintings*, at the Norlyst
Gallery, New York 1947 [8]

THE LIMITS OF THE CANVAS

*These are paintings of a city dweller . . . brown stone
houses and jails . . . the bee sleeps in the dark and her
domain is the sky. In her reduced geometrical space a
cruel and blind life goes on.* Nemesio Antúnez[6]

Though she is now most widely recognised and
celebrated as a sculptor, the first decade of Louise
Bourgeois's career was dedicated to the production of
paintings and works on paper. Artist Nemesio
Antúnez's poetic statement (above) appears on the
invitation to her second solo exhibition at the Norlyst
Gallery, New York, 1947 (fig.8), in which she showed
seventeen paintings. Also printed on the invitation is
a striking, illustration-like line drawing of a woman
who appears to have her upper-body and head trapped
inside a small-scale house. The woman's naked lower-
half is unmistakably feminine, with curvaceous hips
and tiny feet. The drawing is outlined by a bold
rectangular line, though in the painting of the same
title and date – *Femme Maison* 1946–7 – the floor and
outer line have been removed. Here, the edge of the
stretched linen canvas acts as a frame to contain the
image. The fingers of the woman's right hand (which
appears to be waving from an upper storey) are barely
contained within the very top-left corner of the
picture, whilst her feet are only millimetres above the
bottom edge. She is literally boxed-in by the limits of
the canvas (fig.7).

Bourgeois created a series of *Femme Maison* paintings
between 1945 and 1947. The *femme maison* (which
could be translated as either woman-house or house-
wife) is clearly an absurd and pitiful tragi-comic figure.
Her mismatched head and body bring to mind the
popular Surrealist game of 'Exquisite Corpse', also
known as 'Consequences'. Cutting her off at the chest
or waist, Bourgeois's house leaves the woman's
bottom half fully exposed. It is not clear if these are

miniature dolls' houses, or if the woman has grown –
Alice-in-Wonderland-style – to such a size that she is
bursting free of her confines. In one painting, her
splayed legs actually morph into a tall multi-storey
building, whilst three arms escape from the top
windows. In others, hair flies out from the roof or
chimney (fig.6).

With her head trapped inside the house and her
legs vulnerable to exposure, yet strong enough to
carry the weight of her domestic situation, Bourgeois's
Femme Maison came to represent the situation of
being female, or more specifically of being a woman
artist, when she found herself reproduced on the cover
of art-writer and curator Lucy R. Lippard's influential
collection of feminist essays on women's art, 'From
the Center', nearly thirty years after the Norlyst
Gallery exhibition. In the late 1940s, when she first
created the image, Bourgeois was beginning to find
her feet as an artist, jostling for space in the New York
art scene, and as a mother, with limited time and space
to dedicate to her work amidst the daily pressures of
domestic responsibility. Bourgeois made various
small sculptures and drawings of *Femme Maison* at
different times throughout her career. She also
revisited in various ways the houses of her childhood
and early adult years. Her interest in the links between
one's physical home and one's psychological dwelling
place are well documented. Though her life and work
saw many twists and turns, she arguably lived with her
head at least partially trapped in the houses of her past
and present for nearly eight decades.

Louise Joséphine Bourgeois was born in Paris on 25
December 1911. Her father Louis Bourgeois and
mother Joséphine were in the business of restoring
and selling medieval and Renaissance tapestries.
Though Louis hoped that she would continue to work
for the family business, Joséphine was supportive of

Fernand Léger
STUDY FOR CINEMATIC MURAL.
STUDY II 1938–9 [9]
Gouache and pencil on board
50.2 x 38
The Museum of Modern Art,
New York. Given anonymously

her daughter's early ambitions, wishing her to be educated. Louise first began to pursue a serious interest in art and art history in 1933, at the age of twenty-one. Though as a child her drawing skills had been put to use in the tapestry-restoration workshop, she initially chose to study mathematics, physics and chemistry. After an extended period of illness during which Louise took up the responsibility of acting as her nurse, Joséphine died in 1932, and Louise's 'world came apart'. That same year, Louise became a student of calculus and geometry at the Sorbonne. She has spoken widely of her early passion for Euclidean geometry, a system that represented stability and order, and of her disappointment upon discovering that her academic first love was in fact problematic (since Einstein's theory of general relativity shed a different light on the properties of physical space). This must have been a double disappointment to a young woman who sought refuge in the certainty of geometry, a safe haven away from her tumultuous family life.

In the mid-1930s, Bourgeois set out on a new path, entering a brief period as a student at the École des Beaux-Arts in Paris. She then studied in various artists' studios in Montparnasse and Montmartre. Most notably, she acted as *massière* (assistant) at the Académie de la Grande Chaumière in the studio of Yves Brayer during 1936–8, where her role was to hire the models for life drawing. She also studied under Marcel Gromaire, André Lhote and Fernand Léger in 1938 (fig.9). Bourgeois later recalled that it was Léger who encouraged her work in three dimensions.

Letters and diary entries from the late 1930s demonstrate Bourgeois's attentiveness as a young student keen to learn the formal 'rules' of painting in order to master the art. In a letter from 1938 addressed to Colette Richarme, with whom she made friends at the Académie de la Grande Chaumière, Bourgeois expresses her excitement at discovering that the lessons of geometry could be applied to the practice of painting: 'I spent two weeks with André Lhote and I learned so much...the basis of his teaching is that a canvas is an arrangement of lines, surfaces and volume on a plane.' Yet, in the same letter she shows her awareness of the necessity to develop one's own style: 'Read Lhote, who will teach you a lot...you can be extremely personal, and he will understand you and be able to encourage you in *your* way. Whatever you do, don't try to copy him. Fortunately he does nothing to encourage that, unlike the painters mentioned above who try to found "schools".'[7]

Bourgeois's early distain for artistic 'schools' was to stay with her for the remainder of her career. In interviews and writings she was careful to thwart attempts to label her practice according to a particular style or movement. In Paris in the 1930s she was certainly exposed to the work of the Surrealists. In 1936 she rented an apartment in the same building as André Breton's gallery Gradiva. But while their influence may be evident in her work, she repeatedly stressed that she did not see herself as a Surrealist and that in her opinion women were only truly welcome within the Surrealist circle if they were prepared to play the role of sexual partner and/or artistic muse.

Bourgeois opened her own small gallery for a short time in 1938, selling prints and paintings by artists such as Odilon Redon, Henri Matisse and Pierre Bonnard. The gallery was housed in a space that she had partitioned off from her father's tapestry showroom. It was here that she met her future husband Robert Goldwater, an American scholar who later became an eminent art historian. They married quickly and Bourgeois joined Goldwater in New York in October 1938. Bourgeois has said of him:

THE RUNAWAY GIRL c.1938 [10]
Oil, charcoal and pencil on canvas
60.9 x 38.1
Private collection

He rescued me from myself. He felt the same way. He felt he was a prisoner of a very orthodox set-up, and by marrying a French woman, who is supposed to be sexy, he broke away. He destroyed the effect of his family on him ... I would say we were liberators. We liberated each other ... and that is why we got along.[8]

Bourgeois's letters and notes from her first years in New York reveal both her concerns about being away from France during the war, and her lack of confidence in her own abilities as a painter. Though the Goldwaters moved in artistic circles, Louise wrote again to her friend Colette of feeling overawed after she had seen an exhibition of four hundred paintings by Picasso: 'It was so beautiful, and it revealed such genius ... that I did not pick up a paint-brush for a month. Complete shutdown.'[9]

After arriving in New York, Bourgeois enrolled at the Art Students League, where she was mentored by influential artist and teacher Vaclav Vytlacil. Her paintings from this early period are often personal, symbolic and nostalgic, with highly emotional subject matter. In *Reparation* c.1938–40, for example, Bourgeois depicts herself as a young girl bringing flowers to her grandmother's grave. The rich blue dominating the painting suggests that it is night-time, or perhaps a moment of peaceful reflection. *The Runaway Girl* c.1938 (fig.10), shows her, bag in hand, floating over a divided landscape, the past presumably behind her, the future not yet in the picture. At the top left of the canvas is a house, which may represent her childhood home, and a figure in water, possibly recalling Bourgeois's traumatic childhood memory of attempting to drown herself in the river Bièvre during a particularly intense spell of anger and resentment towards her father. Alternatively, the swimmer may simply represent the struggle of the journey, the distance, separated by water, between Bourgeois and

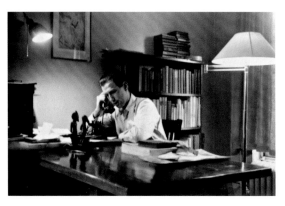

Robert Goldwater at his writing desk
at their home at 63 Park Avenue in
New York, 1939 [11]

her native France: 'When the runaway girl left the coast of Normandy and said: Bye-bye past.'[10]

By 1944, Bourgeois's paintings began to be characterised by their grid-like, boxed compositions, with heavy use of line, strong shapes and blocked colours, reflecting the Cubist influence of her teachers. In a letter from 1939 she again gives advice to Colette:

From what I consider to be the true viewpoint of a twentieth-century artist ... I should say this: renounce skill, shun it. On a practical note: (1) work in black and white, forms and values; (2) in colour, paint only patches of colour, and banish black and white from your palette. Light will be a warm ochre, and shade will be blue, with no attempt at drawing.[11]

Having outlined the traditional distinction between line and colour and their application in building a painting, Bourgeois follows with the declaration: 'I myself have used no colour for a year.' The opposition of line and colour, which has been prevalent in western art and philosophy since Aristotle, tends to subordinate colour (associated with the emotions, the feminine and the primitive) to line (associated with the intellect, the masculine and the rational). Though line alone is used in many of Bourgeois's early drawings and prints, her use of colour is striking in both her later drawings and the paintings she produced in the 1930s and early 1940s.

Aside from the influence of her tutors and mentors, Bourgeois was also likely to have been affected by her husband's scholarly interest and taste in art. In 1938, shortly before the Museum of Modern Art acquired Picasso's *Les Demoiselles d'Avignon* 1907, Goldwater published his PhD thesis as the seminal book *Primitivism in Modern Painting*. He later became the first Director of the Museum of Primitive Art (fig.11). The influence of 'primitive art' (which included tribal art from Africa, the South Pacific and Indonesia) was

seemingly unavoidable in 1930s Paris, where Bourgeois began her artistic training. Lhote lent objects from his private collection to an exhibition of African tribal art in the 1920s. Léger had looked at African sculptures whilst designing costumes for the ballet. The Cubists and the Surrealists took on, developed and defined primitivism in many different ways, but a shared tendency may have been the desire to break away from a learned, urban sophistication and return to more honest and basic forms of expression. At times they turned to the natural world in order to uncover the bizarre mysteries within the most basic elements of life.

Bourgeois's painting *Natural History No.2* 1944 (fig.12), incorporates aspects of Cubism, Primitivism and Symbolism. The painting represents the life of a plant in three parts and the canvas is divided correspondingly into three vertical sections painted in earthy shades of brown, ochre, black and blue. In the centre, the whole plant is depicted, with its roots spreading along the bottom edge of the canvas, its stem and leaves pushing up to the top. Two very simplistically shaped birds sit on either side. The left-hand section of canvas appears to show the plant's fruit and on the right are its flowers. In 1944 Bourgeois wrote a statement about the work, which was later published in the catalogue for a group exhibition, titled *Personal Statement: Painting Prophecy 1950*. Speaking of 'the richness and feel of the pigment, the tangible quality of the surface', and 'the possibilities of surface',[12] Bourgeois's statement reveals the ambition she held at the time to be accepted and respected as a painter. Her subject matter may seem unusual in relation to the *Femme Maisons* and other paintings that she was also producing, but this early work demonstrates an interest in natural forms, in growth and germination, themes that recur in her organic

NATURAL HISTORY NO.2 1944 [12]
Oil on canvas 66 x 111.7

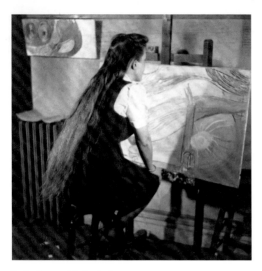
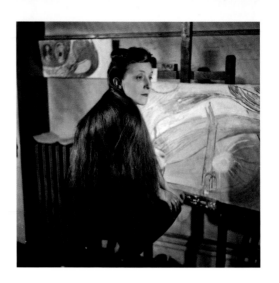

Louise Bourgeois in the studio
of her apartment at 142 East 18th
Street, New York, c.1946 [13a, b]

sculptures of the 1960s and in later prints and drawings. The picture also contains the seeds of her interest in contradictory, ambivalent forms: 'These three stages of evolution in the plant are at once consecutive and interdependent; they are, at different times, both part and whole.'[13]

In the mid-1940s Bourgeois was exhibiting alongside American artists of her generation such as Willem De Kooning, Robert Motherwell, Jackson Pollock and Mark Rothko. The influence of the European Surrealists who had arrived in New York during the war years could be felt in this younger generation of painters, who were balancing the drive towards abstraction with more direct, expressive subject matter. Though her works of the late 1940s move towards the highly charged figurative, symbolic and psychological realm that one would associate more readily with Surrealism, Bourgeois repeatedly rejected this label and instead underlined her understanding of herself as an Existentialist, an affinity that must have begun at this time in her life. Existentialism became the dominant philosophy within artistic circles in Paris and New York in the postwar years, reflecting the desire to return to an emphasis on the choices and freedoms of the individual, on authenticity and a belief that these ideals are meaningful when lived and expressed through art. Apart from her developing philosophical outlook, Bourgeois appears to have shared with her American contemporaries a frustration with the limits of pictorial representation and the traditional two-dimensional surface provided by the stretched canvas. Jackson Pollock famously developed an 'all-over' style of painting that dispensed with formal composition and easel-painting, working with his canvases on the floor, and finding meaning in the movement and application of paint, which he flicked,

poured and splattered beyond the edges of the stretcher frame. For Bourgeois, freedom was to be found elsewhere.

Photographs from 1946 show Bourgeois in her studio (figs.13a, b), perched on a stool in front of her easel with a painting in progress. In one of the pictures she has her back turned to the camera so that her strikingly long hair can be seen flowing down her back, the ends reaching her bottom. She is looking at her painting, but not working on it. Her hands are resting on her knees, her feet tucked up onto the stool. On the right-hand side of the painting in front of her, a tall column-like tower topped by three tiny leaning figures is visibly depicted amidst a landscape of swirling shapes and lines. The left side of the picture is obscured behind Bourgeois's head and upper body. In another photograph she has her face turned towards the camera, with her hair this time draped across her shoulders and back like a shawl. Though she is not looking directly at the camera, her composure suggests that she is posing for the photographer. In this picture a crudely rendered face on the canvas is peeping out from behind the artist's hair and we can see that some of the swirling shapes on the painting are in fact free-flowing tresses. The painting, *Untitled* 1946–7, and a similar work *Roof Song* 1946–8 (figs.14, 15), both show female figures in the open spaces of the city roof-tops, occupying the skyscape with their wild hair and manic expressions. The woman in the foreground of *Untitled* has a large gaping black hole for a mouth, rather like the figure in Edvard Munch's famous painting *The Scream* 1893. In *Roof Song* she has a huge, cartoon-like grin.

What is striking about both of these photographs of the young artist is the dichotomy of her neat, seemingly 'contained' physical situation and the wildness of both her uncut hair and the image we can

UNTITLED 1946–7 [14]
Oil on canvas 66 x 112
Collection Ginny Williams,
Courtesy Ginny Williams
Family Foundation, Denver

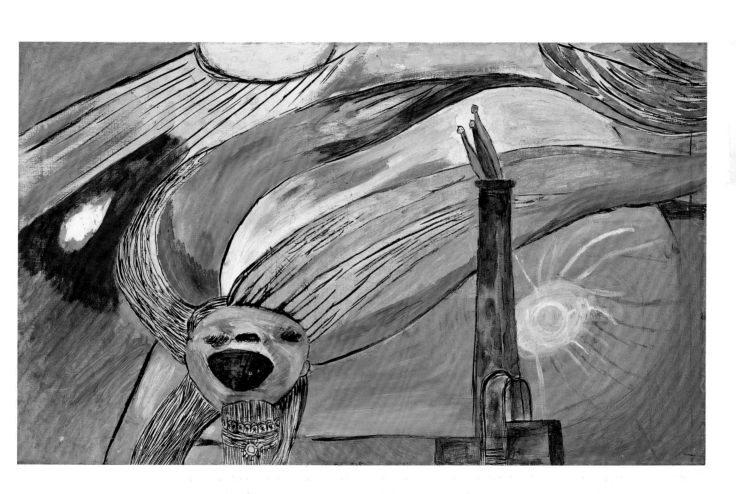

ROOF SONG 1946–8 [15]
Oil on linen 53.3 x 78.7
Private collection, New Jersey

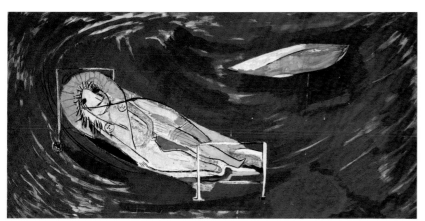

RED NIGHT 1946–8 [16]
Oil on canvas 76 x 152.5
Daros Collection, Switzerland

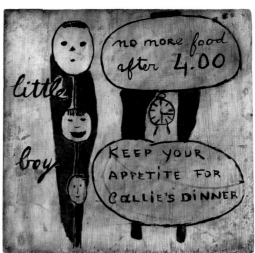

LITTLE BOYS: NO MORE
FOOD AFTER 4.00 C.1945 [17]
Oil on canvas 26.6 x 28.5
Collection Alain Bourgeois

make out in the painting. Many of her works from this time – the roof paintings, the *Femme Maison paintings*, pictures of prisons or domestic spaces – communicate an overwhelming sense of claustrophobia or desire to break free. In the painting *Red Night* 1946–8 (fig.16) a woman lies in bed with her back turned to an open window with a curtain blowing. The curtain and the bed are the only indicators of domestic space; the rest of the picture is dominated by vibrant red swirling strokes of paint, giving the picture a feeling of turbulence. In place of her breasts and between her legs are the small round faces of her three children, whom she appears to be protecting. The faces of Bourgeois's three boys, Michel, Alain and Jean-Louis, also appear in an oil-on-canvas painting from c.1945 titled *Little Boys: No More Food after 4.00* (fig.17), which is perhaps the most direct representation of Bourgeois's daily life and her role as a mother at that time. The picture integrates text with simple, child-like black outlines of faces and a clock, having more in common with Bourgeois's ink drawings than with her paintings of the period. The text reminds the little boys, 'Keep your appetite for Callie's dinner'. A woman making artwork about her lived reality and domestic life may not seem unusual from a contemporary perspective, but in the mid-1940s there was no major legacy of feminist art practice upon which to draw. In their representation of the physical and psychological pressures of domestic life, Bourgeois's paintings made a radical move, one that enabled others to follow her lead, to find ways of presenting, discussing, questioning or validating their experience as women artists.

Bourgeois was not only fighting for the physical and mental space in which to make her art (and, through its making, to take herself seriously as an artist), she was also struggling to find a medium, a

language and a vocabulary that would ring true to her and become her own. In the years that followed, she abandoned the practice of painting and found her freedom of expression in sculpture, extending her studio space onto the roof of the building in which her family lived. It wasn't enough just to escape the 'house styles' that she had so despised as a young artist gaining experience in the Parisian studios; she also needed to escape the claustrophobic confines of the canvas itself, and her desire for something solid led her to work in three dimensions in search of what she called a 'fantastic reality'.

Unlike the other *Femmes Maison*, with their feet on the ground and their heads trapped inside their houses, Bourgeois's *Fallen Woman* (fig.18) appears to have come from the heavens, and to have landed head-first on top of a square-shaped multi-storey building. Her face and hair are clearly depicted in the bottom-left corner of the painting. Her legs tail off into the sky, which is an angry bright red. If the painting were turned upside down, so that the blue section were seen as the sky and the red as the earth, then it would appear as if the building had landed on the woman, crushing her with its force like the house in *The Wizard of Oz*, which swirls up into the cyclone and drops Dorothy into the land of Oz.

Bourgeois's long-standing assistant Jerry Gorovoy has compared her with the central character of *The Wizard of Oz*: 'Like the young runaway Dorothy Gale from Kansas, who appeared in the American popular imagination in 1939, a year after Bourgeois arrived in New York City, Bourgeois has been on a journey to alleviate a core experience of abandonment.'[14] Bourgeois herself declared: 'I was in effect a runaway girl. I was a runaway girl who turned out alright.'[15] Like Dorothy, who falls into a Technicolor Oz from a black-and-white reality, Bourgeois was dazzled by the brilliance of the New York sky:

Do you know the New York sky? You should, it is supposed to be known. It is outstanding. It is a serious thing. Can you remember the Paris sky? How unreliable, most of the time grey, often warm and damp, never quite perfect, indulging in clouds and shades; rain, breeze and sun sometimes managing to appear together. But the New York sky is blue, utterly blue. The light is white, a glorying white and the air is strong and it is healthy too. There is no foolishness about that sky. It is a beautiful thing. It is pure.[16]

The red, white and blue of the painting reflect the colours of the flags for both the country from which she was running, and the new land of hope and freedom. 'Even though I am French, I cannot think of one of these pictures being painted in France. Every one of these pictures is American, from New York. I love this city, its clean-cut look, its sky, its buildings, its scientific, cruel, romantic quality.'[17]

Bourgeois's preference for the colours red and blue is evident throughout her career. The two colours are juxtaposed in works such as *Red Room (Child)* 1994 (fig.59) and in a large number of prints and drawings . In 1986 she wrote in her diary: 'Nothing can satisfy the need to cover everything in blue … blue pinches my heart. It's a defence, like overeating sugar.'[18] And later, 'Paint everything in blue, blue, blue, blue, sky – blue, liberty, blue.'[19]

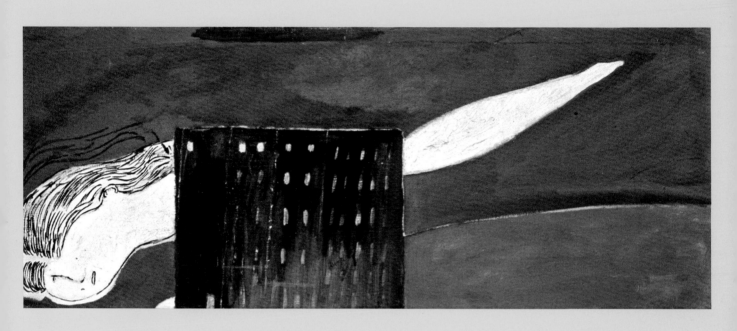

FALLEN WOMAN
(FEMME MAISON) 1946–7 [18]
Oil on linen 35.6 x 91.4
Private collection

Blue and red are like black and white to Bourgeois. They are opposite extremes
– like calmness and passion, or creation and destruction, yet she saw them as
continually coexisting.

Red is the colour of blood,
Red is the colour of paint.
Red is the colour of violence.
Red is the colour of danger.
Red is the colour of shame.
Red is the colour of jealousy.
Red is the colour of grudges.
Red is the colour of blame.[20]

What was Bourgeois afraid of? What was she running from? Was she afraid of fear
itself? She has said: 'My early work is the fear of falling. Later on it became the art of
falling. How to fall without hurting yourself. Later on it is the art of hanging in there.'[21]
The fear of falling may be a fear of falling from grace, falling in love, falling ill, falling
pregnant, falling into a trap, etc. Dancers learn to fall correctly. The art of 'falling
without hurting yourself' is about developing a skill. It is about letting go of rigidity
and inhibitions, making a statement, a leap, yet landing unscathed. For an artist, this
translates as learning to be confident in one's ability to express oneself, remaining
strong despite the vulnerability of continually revealing inner thoughts, desires, feelings
or motivations. From then on, it's about making a habit of creating, continuing to
develop, and to 'hang in there' day by day.

Fallen Woman was revisited by Bourgeois in the 1980s, when she made small,
three-dimensional versions of the figure carved in black or white stone (fig.19). This
phallic, gavel-like object with a woman's head attached is slightly pathetic: 'She's
faithless. She's helpless. She's waiting for somebody to pick her up. You see the arm
of somebody coming, a hand coming to help her? She's nothing.'[22]

FALLEN WOMAN 1981 [19]
Bronze, black and polished patina
34.3 x 8.9 x 8.9

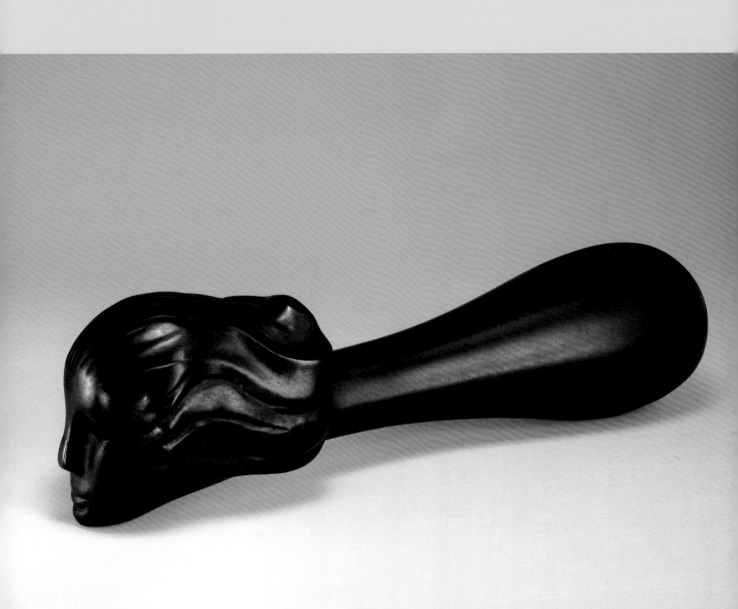

PERSONAGES in Bourgeois's studio at 142 East 18th Street, New York, in the early 1950s [20]

Louise Bourgeois working on her sculptures on the roof of her apartment building in New York, 1944 [21]

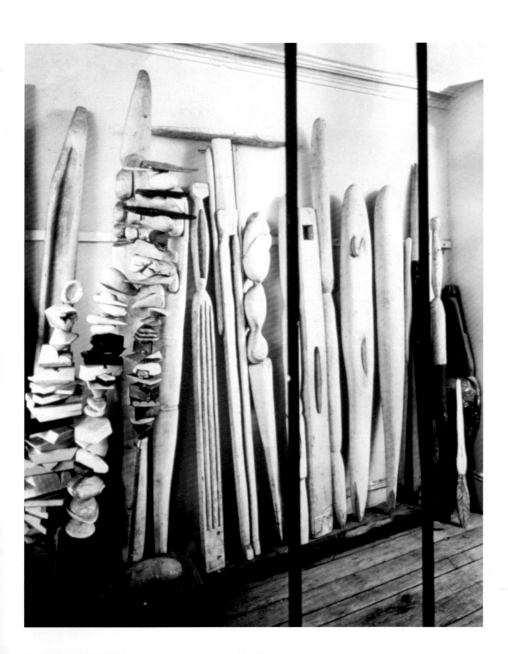

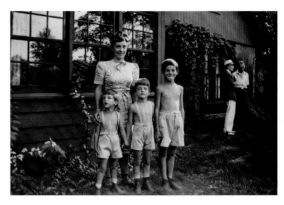

Louise Bourgeois in Easton, Connecticutt, in 1945 with her sons Alain, Jean-Louis and Michel. The artist Charles Prendergast and Bourgeois's husband Robert Goldwater are in the background [22]

2

ASSEMBLAGE AS RESCUE MISSION

I was not a sculptor in France, and I don't think I would have become a sculptor. Because to be a sculptor is a kind of ridiculous position in the sense that the food of an artist is first what he sees when he looks in the streets. Now, in New York everything is dumped on the sidewalk. So you find beds – whole beds – and you find all kinds of household things, as if a whole apartment had been put on the sidewalk. It is not that people abandoned them, but that people are separated from them. Now for an artist, you well understand this can be full of fantastic objects and you look at them and you combine them and that is the beginning of assemblage. It is a rescue mission. You try to save these things because they are so wonderful.[23]

In April 1951 Louis Bourgeois died. Louise was devastated by the death of her father and the settling of his estate. That same year her work *Sleeping Figure* 1950 was purchased for the collection of the Museum of Modern Art. Director Alfred H. Barr Jr., an early supporter of Bourgeois, had seen the wooden figure in Bourgeois's second solo show at the Peridot Gallery. Her debut as a sculptor occurred a year earlier, with the exhibition plainly titled *Louise Bourgeois, Recent Work 1947–1949: Seventeen Standing Figures in Wood.*

Photographs from as early as 1944 show Bourgeois with her new sculptural works-in-progress, both on the roof of her apartment building on East 18th Street, and in the attic and studio spaces (fig.21). These new works took the form of simple, rigid, somewhat totemic wooden standing figures, with areas carved out or basic additions appended to indicate arms, a head or legs – hinting with minimal means that they represent human presences, or *Personages*. The *Personages* did not have sculptural bases and came to a point at the bottom in order to maintain their inherent instability. Bourgeois explained in 1979:

it was a period without feet... During that period things were not grounded. They expressed a great fragility and uncertainty... If I pushed them, they would have fallen. And this was self-expression... Sleeping Figure is a war figure that cannot face the world and is defensive. The face is a kind of mask and the arms are lances... [the Second World War] changed what I was thinking of, it changed what I wanted to express... [my goal was] to be the self without the face... or the base.[24]

In the studio the *Personages* are propped against the wall in a line like so many naughty children (fig.20). Similarly, in pictures taken at the Goldwaters' country house in Easton Connecticut, circa 1945, they can be seen lined up against an outside wall, while in another photograph Bourgeois and her three children stand to attention with their backs to the house in a posed arrangement for the photographer (fig.22). In an interview from 1976, Bourgeois explained how the works had functioned for her before they were presented in the public space of the gallery:

The figures on the roof had nothing to do with sculpture, they meant physical presences. That was an attempt not only at recreating the past but controlling it ... The dynamism of the presence in a claustrophobic space such as the top of the stairs under the roof was much more dynamic than the gallery... But the gallery would not have permitted me to place my Personages in a closet which in effect is the way they were conceived.[25]

At the Peridot Gallery, the *Personages* occupied the space in the room, forcing visitors to navigate their way around the precarious structures. As Bourgeois later explained: 'My personages were first exhibited at the Peridot Gallery in 1949. I installed them in the gallery without bases... When viewers entered the gallery, they encountered these presences as if they were entering a room of real people.'[26]

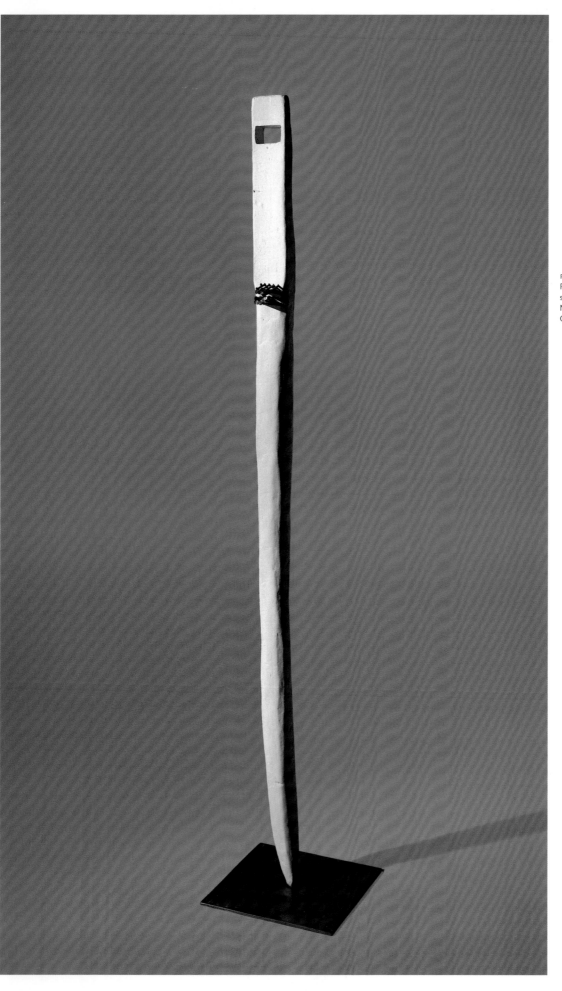

PORTRAIT OF C.Y. 1947–9 [23]
Painted wood, nails and stainless
steel 169.5 x 30.5 x 30.5
National Gallery of Canada,
Ottawa

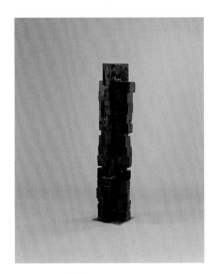

MORTISE 1950 [24]
Painted wood and stainless steel
152.4 x 45.7 x 38.1
National Gallery of Art,
Washington D.C.

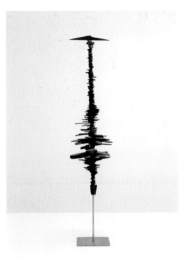

FEMME VOLAGE 1951 [25]
Painted wood and stainless steel
182.9 x 44.5 x 33
Solomon R. Guggenheim
Museum, New York

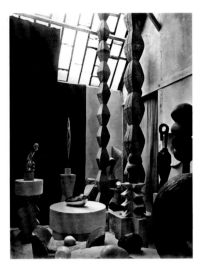

Photograph of the Brancusi studio
with ENDLESS COLUMN [26]

The *Personages* appear to have acted for Bourgeois as tangible reminders of – and substitutes for – her family and friends in Europe:

> It was a recreation . . . of people I missed. They were presences and they occupied the whole room. They represented the people I had left behind – that is to say, my father, my brother, and their family, my cousins, all the people I had left in France. I had come to this country alone. It was a kind of memorial, you might say, I must have felt guilty to have abandoned my family in France. It's as simple as that.[27]

Several of these portable fetish objects were carved and shaped from salvaged pieces of redwood, the timber used to make the circular water towers that characteristically populate Manhattan's rooftops. Though the *Personages* have since been cast in bronze (Bourgeois's ultimate intention) many of the original figures were crudely painted and left with a matt finish, retaining their appearance as worn, whittled, partially reclaimed materials. The individual titles of the *Personages* vary. Some are plainly descriptive (*Winged Figure, Pillar*), whilst others refer more ambiguously to emotional states, with which the artist herself may have been struggling at the time of their making (*Persistent Antagonism, Friendly Evidence, Depression Woman*). Other titles seem to link the body with particular domestic instruments, especially those with the potential to be used either creatively or violently (*Paddle Woman, Needle Woman, Dagger Child, Knife Couple*), as if the sculptures personified not only the processes of carving, cutting and hacking that had brought them into being, but also the aggression and anger that the artist wished to exorcise from her own body and psyche. *Portrait of C.Y.* 1947–9 (fig.23) is the most clearly aggressive of the *Personages*, with nails driven into its front face, and was apparently fashioned as a kind of 'voodoo doll' displacement for

Bourgeois's anger towards a particular acquaintance: 'This piece kept me from doing to her what I did to the sculpture . . . I controlled my feelings through sculpture.'[28]

Given Bourgeois's statement that the *Personages* functioned as a kind of memorial to those whom she had left behind in France, it is likely that these early sculptures were for her the tangible evidence of a process of mourning following the war and the death of her father. On 5 October 1955, Bourgeois became an American citizen. Perhaps her newly established identity finally gave her the freedom to conceive of herself and her development as an artist in fresh ways.

In the early 1950s Bourgeois had also made a series of more abstract, repetitive, stacked wooden pieces by cutting wooden blocks and assembling them on a central pole. Several of these pieces, such as *Mortise* 1950 (fig.24), or *Memling Dawn* 1951, are regularly shaped, modular towers. Others, such as *Femme Volage* 1951 (fig.25) or *Spiral Woman* 1951–2 employ smaller, more organically shaped pieces of cut and painted wood, which are twisted around their armature suggesting a fragile pliability and movement. Storr has described the former, blocked pieces as 'the missing link between Brancusi's *Endless Column* of 1938 [fig.26] and Carl Andre's horizontal fire-brick "stack" *Lever* of 1966'.[29] Bourgeois had met Constantin Brancusi as a girl, when she visited his studio. Like Bourgeois, Brancusi was legendarily inspired by the architecture of Manhattan after a visit in 1926 that had stimulated his first ideas about the *Endless Column*. Perhaps she recalled his seminal forms, if only subconsciously, whilst working in her roof-top open-air studio.

One and Others 1955 (fig.27) is a painted-wood cluster of organic forms, assembled on a base, whose title Bourgeois felt 'might be the title of many since

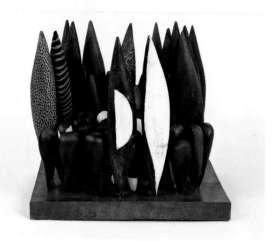

ONE AND OTHERS 1955 [27]
Painted and stained wood
47.3 x 50.8 x 42.8
Whitney Museum of
American Art, New York

QUARANTANIA I 1947–53 [28]
Wood, paintede white with
blue and black 206.4 x 691 x 686
The Museum of Modern Art,
New York
Photo © by Peter Moore

then'. Extending her interest in exploring the relationships between her figures as they were displayed at the Peridot Gallery, the relation between the single figure and the group is played out through several standing sculptures of this period, as well as through works from the 1960s, where rounder, more squat forms are clustered together. In making *Quarantania I* 1947–53 (fig.28), Bourgeois revisited several of her monolithic figures when she decided to bring them together into a group arranged on a single base. Five tall standing figures huddle together, the woman with three 'packages' or children at the centre. The work is usually understood as a representation of the family unit and its title refers to the fact that each element was originally made in the 1940s. Goldwater makes reference to this piece in his discussion of the sculptural technique of assemblage in *What Is Modern Sculpture?* (1969):

By 1950 sculptors made assemblage their own . . . Bourgeois's Quarantania I *takes the method of assemblage at its most literal. Each of the wooden elements, painted white or blue, is a separate unit anchored to a base that serves as common ground for a concentrated gathering of carved abstract shapes. Similar but not identical, their rhythms and relations give the work its formal interest. At the same time, as the attenuated organic curves suggest, there is a symbolic reference. Here is a human group, its members alike but various, leaning towards one another in an intensity of feeling that unites them even as it leaves each one silent and alone.*[30]

The most basic definition of assemblage would describe it as an artistic process whereby found or 'readymade' objects are brought together to make a sculptural composition. Assemblage is therefore a kind of three-dimensional equivalent of collage. Though it has its roots in the Cubist compositions of Picasso, Braque and Gris, and was a key technique for a

number of artistic movements in the early twentieth century – in particular Futurism, Dada and Surrealism – assemblage really gained currency as a term in the 1950s following French painter Jean Dubuffet's series of collages titled the *Assemblages d'Empreintes* (Assembled Imprints). At the beginning of the 1950s David Smith – the most widely celebrated American sculptor associated with the Abstract Expressionists – was making welded iron and steel sculptures, and assemblages often using reclaimed or scrap metal. The influence of Surrealist sculpture and of Alberto Giacometti is apparent in his work. Like Smith and Giacometti (who was actually excommunicated by the Surrealists) Bourgeois looked beyond Surrealism and began to align herself instead with the ideas and enthusiasms that were to become the defining interests of the New York School. Her *Personages* clearly employ the formal sculptural vocabulary of the time in both the totemic free-standing figures and the groups arranged on a base, such as *Quarantania*, many of which could be compared with works by Smith or Giacometti. The *Personages* have a primitive quality, which not only fits the sculptural aspirations of the time but also arises from the artist's own relationship to them as fetish objects. Bourgeois's sculptural assemblages were perhaps more unusual in being portable and – as installed in the Peridot Gallery – 'environmental'. Even at this early stage in her career she was using assemblage in order to gather together substitutes for and fragments of her past.

In 1961 the Museum of Modern Art staged *The Art of Assemblage*, an exhibition that surveyed the development of assemblage through the first half of the twentieth century and included a wide range of recent contemporary works made in 1959, 1960 and 1961 by American artists such as Edward Kienholz, Louise Nevelson, Alfonso Ossorio and Kay Sage, and

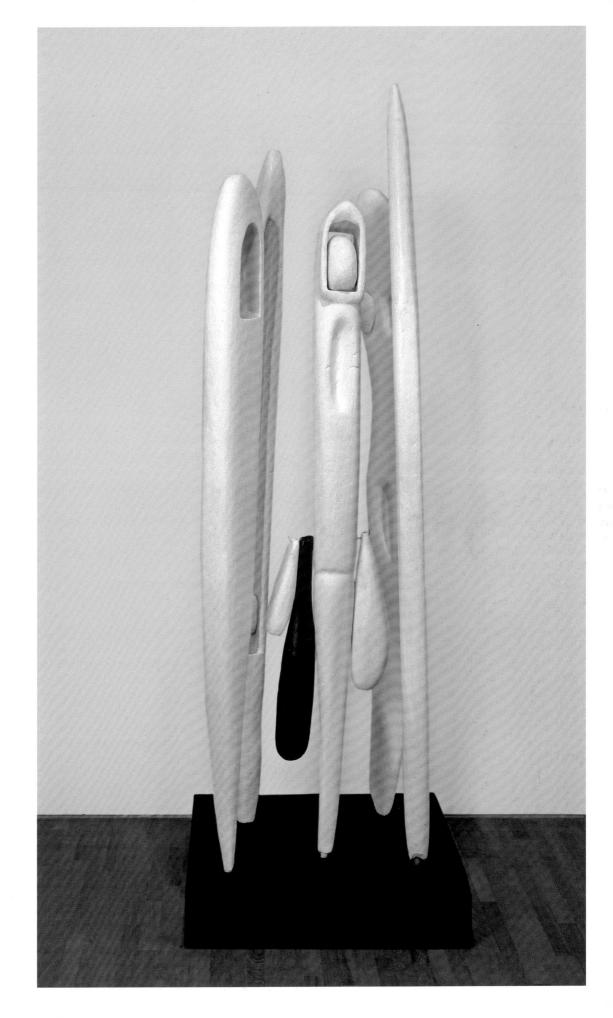

by European artists, including a particularly focused selection of works by the Nouveaux Réalistes. In his extended essay for the exhibition's catalogue, curator William C. Seitz writes: 'The current wave of assemblage owes at least as much to abstract expressionism (with its dada and surrealist components) as it does to dada directly, but it is nevertheless quite differently oriented: it marks a change from a subjective, fluidly abstract art toward a revised association with environment.'[31] Seitz talks about the 'collage environment', explaining that 'the tradition of assemblage has been predominantly urban in emphasis' and 'the proper backdrop for recent assemblage is the multifarious fabric of the modern city'. In particular, New York is seen as the ultimate symbol of modern existence, exerting its influence on a raft of European and American artists who lived and worked in the city in the postwar years. Between the mid-1950s and early 1960s, Robert Rauschenberg was incorporating items that he found on the streets into his 'Combines' – works that combined elements of painting and sculpture. In the early 1960s and with the development of Pop art, artists began more than ever to incorporate elements of the urban environment into their art. Assemblage became less about the strange and uncanny juxtapositions and collections of found objects that fascinated the Surrealists, and more about the immediacy of popular culture and life on the street with both its junk and detritus, but also the bright and shiny world of advertising, cinema, nightlife, etc.

Bourgeois spoke extensively about the influence of the New York skyline on her work in the late 1940s and early 1950s, and it is in evident in her paintings, drawings and etchings from the period, and in the *Personages* that she constructed from reclaimed timber on the rooftop of her apartment. New York enabled her to adopt the technique of assemblage and to work with salvaged materials for years to come. However, her career-long use of assemblage had less to do with an attempt to reflect her external environment than with her interest in the landscape of the mind, the emotional inner-worlds that she continued to fashion and shape into 'fantastic reality'. In this regard, her work often has more in common with Surrealist sculpture than with the Pop art or Nouveau Realiste assemblages of the 1960s.

In her later work, especially the *Cells* (which will be considered more fully in chapter 4), Bourgeois incorporated found objects and items accumulated over the years that had a particular emotional charge and resonance for her. Closets of clothes that she kept for decades were plundered as materials that speak eloquently of her past lives; glass jars are stacked together (fig.29); old mirrors, perfume bottles, chairs, tins, needles and spools of thread, salvaged doors, old bones . . . these items densely populate her pieces, creating a particular aesthetic and charging her work with aspects of the past in a form of historical recovery. In the case of her old clothes and other personal items, this sculptural strategy had the added advantage of enabling the artist to offload her material and psychological baggage, but also to preserve the fragments of her life for posterity. In an interview of 1986, Bourgeois stated:

Assemblage is different to carving. It is not an attack on things. It is a coming to terms with things. With assemblage or the found object you are caught by a detail or something strikes your fancy and you adjust, you give in, you cut out and you put together. It is really a work of love. But there is something else in assemblage, there is the restoration and reparation. Mind you, this is what my parents did, they restored and repaired tapestries, so there is a common attitude. To repair a thing, to find something broken, to find a tapestry torn apart with big holes in it

LE DEFI 1991 [29]
Painted wood, glass and
electrical light 171.5 x 147.3 x 66
Solomon R. Guggenheim
Museum, New York

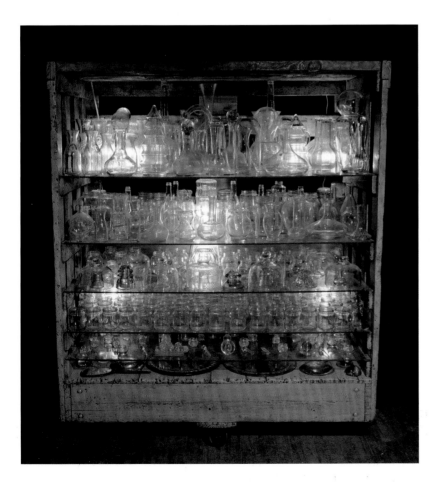

*and destroyed and step by step to rebuild it – making an
assemblage is that. You repair the thing until you remake
it completely.*[32]

Bourgeois thus set up a dichotomy in her practice
based on the psychological significance of different
processes of making. Her explanation is in many ways
counter to the traditional, romantic understanding of
the sculptor as a creative genius, slowly chiselling and
hacking away to release the shape he sees within the
stone. In Bourgeois's work, the act of carving is an
immediate expression of aggressive or even destructive
drives. Neither is assemblage the quick and
spontaneous method of choice to reflect contem-
poraneity; rather, it is an act of slowly repairing,
salvaging and revisiting aspects of the past to make
something new. Interestingly, she continued to use
both methods of making in various ways and at
various different times throughout her career. Though
Bourgeois began to engage with techniques of
assemblage in the post-war years with the making of
her *Personages*, the development of her work and its
motivations took her further away from the spare
aesthetic associated with Brancusi (and taken to its
logical conclusion in the Minimalists' use of industrial
materials and serial elements) and closer to a
sculptural language that may be associated with
bricolage, or even – in her work of the 1960s – with the
pre-industrial or pre-modern.

The Blind Leading the Blind 1947–9 (fig.31) is the largest and perhaps best-known of Bourgeois's early sculptures. The original version, titled *The Blind Vigils*, was included in the Peridot Gallery exhibition in 1949, where it was positioned against a wall. Bourgeois later preferred the piece to be seen as a stand-alone installation. There are five versions of *The Blind Leading the Blind*, distinguishable by the number of vertical 'legs' and the paint colour: a red and black version that belongs to the artist; a black version in the collection of the Detroit Institute of Arts; and three pink versions in the National Gallery of Australia, the Hirshhorn Museum and Sculpture Garden in Washington, and the Des Moines Art Center.

The sculpture has an architectural quality. Standing at approximately 172 cm high, the vertical posts are held together by a horizontal lintel or cross-beam at the top. In a photograph from 1966 Bourgeois is positioned standing behind *The Blind Leading the Blind* (fig.30), making it apparent that in relation to her diminutive frame the openings between each post could act as narrow doorways. The basic post-and-beam structure is mirrored in the later *Maisons Fragiles* 1978, a further reminder of Bourgeois's ongoing interest in the relationship between the body and the house. Both works also seem to defy gravity with their precarious balance. Seeing *The Blind Leading the Blind* as a giant multi-legged creature with its regimented, tapered limbs, there is no doubt that it would be fast-moving if each leg had been jointed, but the rigidity impairs the creature, like the ladders that lead to nowhere in Bourgeois's etchings, or the spindly rubber *Legs* 1986 that simply hang against the wall, the feet never quite reaching the ground.

The title is taken from a well-known adage that originates in a biblical passage from the gospel of Matthew (15:14), where Jesus says: 'Let them alone: they be blind leaders of the blind. And if the blind lead the blind, both shall fall into the ditch.' An earlier text, from the Hindu *Katha Upanishad* written around 800–200 BC, similarly states, 'Abiding in the midst of ignorance, thinking themselves wise and learned, fools go aimlessly hither and thither, like blind led by the blind.' The Christian parable is pictured by the Flemish artist Pieter Bruegel the Elder in a painting that Bourgeois admires, *The Parable of the Blind* 1568 (fig.31). In 2008 Bourgeois was given the opportunity to show her sculpture alongside this painting, where it hangs in the Museum of Capodimonte in Naples. Breugel's painting is doubtless an allegorical account of the political follies of his contemporaries. Similarly, Bourgeois referred to *The Blind Leading the Blind* as her response to the trauma of being investigated by the House Un-American Activities Committee along with Marcel Duchamp and Amédée Ozenfant. The title reflects her

disdain for both the anti-communist investigators and her artistic 'father figures':
'Breton and Duchamp made me violent. They were too close to me and I objected
to them violently – their pontification. Since I was a runaway, father figures on these
shores rubbed me up the wrong way. *The Blind Leading the Blind* 1947–9 refers to the
old men who drive you over the precipice.'[33]

Bourgeois also spoke about the sculpture's title as a reflection of her anger
at being forced to 'turn a blind eye' to her own father's behaviour and his failure to
set an example:

Blind Vigils *is like* Blind Leading the Blind. *Blindness came from the blush I experienced
at the side of the people around me, everybody. As I say, my father was promiscuous. I had
to be blind to the mistress who lived with us. I had to be blind to the pain of my mother. I had
to be blind to the fact that my sister slept with the man across the street. I had an absolute
revulsion of everybody – everything and everybody.*

THE BLIND LEADING THE BLIND 1947–9 [31]
Painted bronze, and stainless steel
177.8 x 166.3 x 41.9
Installed at the Museo Nazionale di Capodimonte,
Naples, in 2008 with the 1568 painting THE PARABLE
OF THE BLIND by Pieter Bruegel the Elder

Louise Bourgeois in the studio of
her home with some of her plaster
sculptures, including CLUTCHING
and AMOEBA, c.1965 [33]

FORMED AND FORMLESS, CAST AND CARVED

3

*Within the art (as, one suspects, within the artist) form and
formless are locked in constant combat.* Lucy R. Lippard[34]

Louise Bourgeois held no solo exhibitions of her work
between the years 1953 and 1964. She opened a small
shop on Madison Avenue specialising in the sale of
prints, and also took up teaching positions in Brooklyn
and Long Island. In 1962 Goldwater and Bourgeois
moved to the Chelsea brownstone she occupied until
her death in 2010. Much has been written about the
congruence between her use of the basement as a
studio and the development of her work throughout
the 1960s and 1970s. Her exhibition at the Stable
Gallery in 1964 brought together a group of sculptures
that were surprisingly different in shape and material
from the tall, rigid *Personages* that she had shown
some eleven years earlier. These new works marked a
change 'from rigidity to pliability'. Now her sculptures
were mostly rounded, squat, amorphous lumps made
of plaster or latex, crouching on low plinths or hanging
from the ceiling. As the critic Daniel Robbins wrote in
his *Art International* review of the show, 'It was as if
an old acquaintance once darkly lean, elegant and
aloof, had come back from a long journey transformed:
fleshy, chalky, round and organic.'[35] These new works
were suggestive of organic matter, the most basic life
forms (*Amoeba* 1963–5), or places of animal refuge
(*Lair* 1962; fig.32). Perhaps Bourgeois had found her
own refuge in the dark basement – its floor lined with
large, roughly rounded, flood-resilient stones,
reminiscent of the multiple rounded elements
incorporated into her works throughout the 1960s.
Perhaps here she had found her own safe place in
which to hide away whilst experimenting with new
materials and forms, daring to make and eventually to
exhibit her most base, scatological and seemingly
'formless' sculpture (fig.33).

Though it is true that Bourgeois's practice was
studio-based, her works formed and characterised
partly as a result of the locations in which they were
produced, she did not work entirely in isolation. Her
work developed in line with the prevailing attitudes of
the times, changes in her use of media and materials
being at least partially informed by the artistic
communities in which she lived and worked. In 1966
the young writer and curator Lucy Lippard chose to
show Bourgeois's amorphous plaster and latex pieces
in an exhibition that she titled *Eccentric Abstraction*,
held at the Marilyn Fischbach gallery in New York.
Lippard wanted to show a parallel trend to cool, hard-
edged Minimalism with its use of industrial materials.
Her exhibition included Eva Hesse, Keith Sonnier and
Bruce Nauman, younger artists who shared Bourgeois's
interest in using new materials like latex and plaster,
and who made works with a more organic aesthetic.
Lippard has said, 'The work I was looking for was
abstract and formally simple, with rough edges and
erotic undertones . . . I was struck by this artist from an
older generation who had come up with something so
fresh and forceful, even in the context of the other
youthful work.'[36]

For Lippard, the *Eccentric Abstraction* exhibition
marked the start of a significant period in art practice
in the late 1960s that was outlined more fully in her
important book *Six Years: The Dematerialization of the
Art Object from 1966 to 1972*. The book charts the
chronological development of Conceptual and
process-based practices throughout this period,
exploring how artists in North America and Europe
were engaged in different attempts to remove the gap
between the idea, concept and/or process of making
and the resulting artwork. The traditional way of
understanding an artwork in terms of form and
content or style and subject matter no longer held

Lynda Benglis
QUARTERED METEOR 1969/1975 [34]
Lead 150 x 168 x 158
Tate. Lent by the American Fund
for the Tate Gallery, partial purchase
and partial gift of John Cheim and
Howard Read 2009

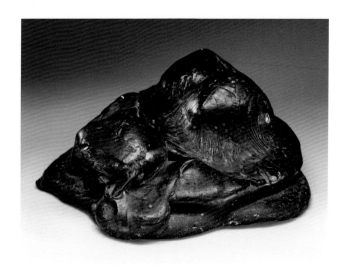

SOFT LANDSCAPE I 1967 [35]
Plastic 10.1 x 30.4 x 27.9

sway. The artists associated with this period and type of practice were not concerned with revealing their personality or soul, nor in any kind of emotional content. Indeed, they attempted to remove all trace of the 'artist's hand', preferring instead to use found objects or to explore the properties of materials for their own sake. Robert Morris's seminal essay 'Anti-Form' was published in the April 1968 issue of *Artforum* magazine. The essay defended a change in Morris's practice, moving away from the hard-edge aesthetic towards a materials- and process-based sculpture where gravity, viscosity, etc became the actual subject of the work. Morris cut up pieces of felt and let them drape and hang from the wall in a random manner. Around the same time, Lynda Benglis (who later collaborated with Morris), was making poured works using wax, latex, plastics and paint, objects that made ironic reference to the macho 'gesture' of Abstract Expressionist painting, and were intended to disrupt the dominant – also masculine – Minimalist aesthetic (fig.34).

Looking at Bourgeois's work of the early to mid-1960s, the unformed lumps of plaster concealing fleshy latex interiors, the skeins and the spirals, it is easy to see why Lippard was keen to include her sculptures among those she titled 'Eccentric Abstraction' and defined as being 'more closely related to abstract painting than to any sculptural forms', yet also Surrealist in spirit.[37] However, unlike some of the other artists whom Lippard invited to take part in *Eccentric Abstraction*, Bourgeois was always driven by her desire to say something, rather than to simply explore materials. As with the *Personages*, many of Bourgeois's sculptures from this period appear at first sight to be abstract, though often the titles bring them back towards the figurative, referring to natural environments, as in the *Soft Landscapes* (figs.35, 36);

animal habitats or shelters, as in the *Lairs*; or human representation, as in *Portrait*, *Self-Portrait*, *Heart*, *Figure*, etc. For her, materials were only interesting insofar as they could be used to express certain emotional or psychological states, or to indicate the places of human or animal refuge where those states are played out. As she said:

The medium is secondary to me ... the wish to say something antedates the material ... I'm not saying that materials are not important. I love materials ... When you want to say something, you consider saying it in different ways, just as a composer would play in different keys, or different instruments. Little by little, and generally by a process of elimination, after trying everything else, I find the medium that suits me. Sometimes the same idea or subject appears in several different media.[38]

Fée Couturière 1963 (fig.37) is a roughly tear-drop shaped, craggy white piece resembling a hornet's nest that hangs from the ceiling. The first, plaster version was shown in the 1964 Stable Gallery exhibition. Later, the sculpture was cast in bronze, which was then painted white. Various holes and crevices appear on the outside. The viewer can peer into them to get a sense of how the tunnels join up on the inside. The title translates literally as 'Fairy Dressmaker', and alludes to the bird's nest. In Bourgeois's words: 'It's a piece with holes, several floors and is like a labyrinth. You can put your hand in it, and you don't know which is the entrance and which is the exit. It is a kind of bird's nest hanging in a tree.'[39]

A close-up photograph of the interior of this work appeared in *Art International* in 1966 (fig.38). The sculpture resembles the mouth of a cave more obviously than any kind of nest. Several critics have pointed to the influence on Bourgeois of the writer and philosopher Georges Bataille, who was important for the Surrealists and who wrote extensively on the

SOFT LANDSCAPE II 1967 [36]
Alabaster 17.8 x 37.1 x 24.4
Kunstmuseum Bern

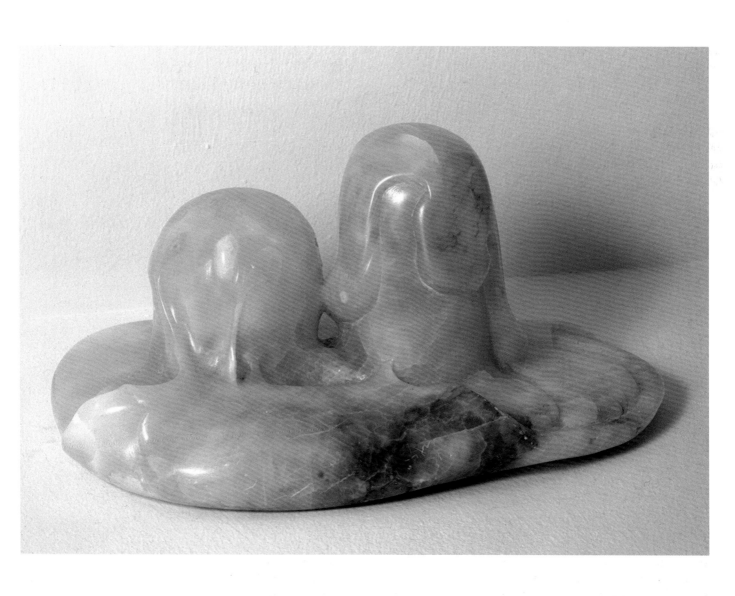

FÉE COUTURIÈRE 1963 [37]
Bronze, painted white,
hanging piece 100.3 x 57.2 x 57.2
Solomon R. Guggenheim
Museum, New York

Detail of FÉE COUTURIÈRE 1963 [38]

caves of Lascaux in south-west France. Bataille's ideas about the *informe* (formless) were developed in the late 1920s in his 'Dictionnaire Critique' (Critical Dictionary), published in the journal *Documents* (1929–30). He famously wrote, '*formless* is not only an adjective having a given meaning, but a term that serves to bring things down in the world . . . What it designates has no rights in any sense and gets itself squashed everywhere, like a spider or an earthworm.'[40] For him, the formless is subversive because of its primitive, undifferentiated quality. It collapses hierarchies and rejects the traditional duality of form and content, and can therefore be a useful position to adopt or explore. When Lippard wrote in her essay 'Louise Bourgeois: From the Inside Out' that 'within the art (as, one suspects, within the artist) formed and formless are locked in constant combat',[41] she was referring to the tension between the underlying form and the seductive or repulsive surface in Bourgeois's works. Lippard's essay explores Bourgeois's ability to work materially and psychically 'from the inside out'.

In her notes from mid-1960s Bourgeois wrote: 'hollow forms first appeared in my work as details, and then grew in importance until their consciousness was crystallized by a visit to the Lascaux caves with their visible manifestations of an enveloping negative form, produced by the torrent of water that has left its waves upon the ceiling'.[42] Her interest in the 'negative form' produced over time at the caves of Lascaux found expression in her work through her use, and subversion, of the casting process. In the traditional process of casting, a sculpture is modelled in clay and a mould is then made, often using plaster and/or latex. Liquid material such as molten bronze is then poured into the mould, which is broken and removed when the interior has hardened. Working directly with plaster or latex, Bourgeois cast and formed shapes using old cartons or whatever she had to hand as a mould with no 'original', or as an armature with which to make the coiled, spiralling pieces. She made works from what are normally the remnants of the casting process, combining them in new ways and presenting what is negative as a positive, what is inside on the outside, and vice versa. She explained:

The ebb and flow of my works is in the pouring, then the cutting. Poured plaster is a material of the twentieth century, made possible by the ever-present packaging and the flexible container – paper, cardboard or rubber – that can be bent, stripped off and thrown away. Once poured, the plaster can be cut and filed, and so reduced, or it can be made to grow and multiply and be transformed before it is cast.[43]

Bourgeois's works from the 1960s can be categorised according to their forms, materials and titles. Certain shapes are repeated, or 'made to grow and multiply' as they are reproduced in different materials or combinations, producing variations upon a theme and developing her distinct vocabulary of sculptural forms. *Labyrinthine Tower* 1962, *Spiral Summer* 1960 and *Lair* 1962 (fig.32) are all spiralling forms made of plaster. The earliest, *Spiral Summer*, is a kind of open knotted structure made of coiled wire covered in plaster and resembling guts. The spiralling towers of *Lair* and *Labyrinthine Tower* are more tightly formed and erect. The spiral holds particular importance for Bourgeois, since it represents 'an attempt at controlling the chaos'. In the case of *Lair*, this shape is built up as a kind of fortress to protect whatever is imagined to be inside. But in all of Bourgeois's spirals – including the articulated wooden *Spiral Women* of the 1950s and the later small hanging bronze *Spiral Woman* (fig.39) – there is always a sense that the strung-up, wrung-out shape could unravel, releasing the tension and spiralling out of control at any moment.

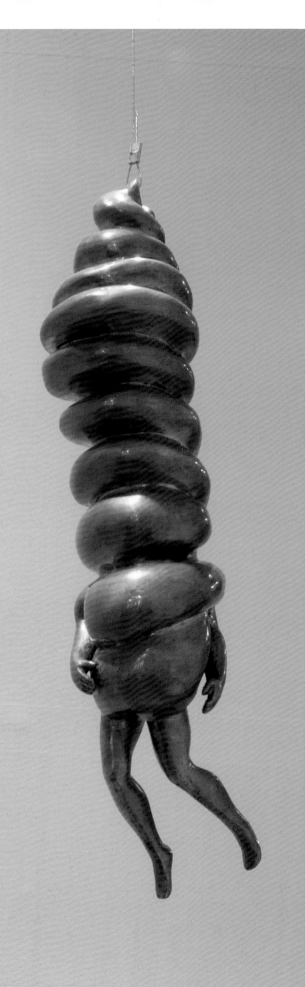

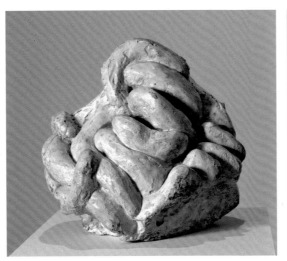

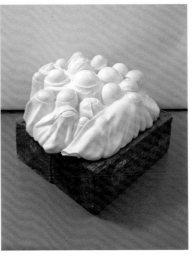

SPIRAL WOMAN 1984, detail [39]
Bronze and slate disc: bronze
48.2 x 10.1 x 13.9; slate disc 3.2 x 86.3
(diameter)

CLUTCHING 1962 [40]
Plaster 30.4 x 33 x 30.4

CUMUL I 1969 [41]
Marble 57 x 127 x 122
Museé national d'art moderne,
Centre Pompidou, Paris

Clutching 1962 (fig.40) looks like several grasping hands that have morphed into each other. This small piece could be seen as a bridge between the spiral pieces and the more amorphous *Soft Landscapes*: small objects made in a variety of materials and mostly produced between 1963 and 1967. The earliest is a latex and plaster lump. Rough, seemingly unformed, scatological and abject, it is more like a small, unwanted clod of earth than any kind of grand landscape. Other *Soft Landscapes* made of plastic resemble poured and set mounds of treacle toffee. The *Soft Landscape* was also carved in alabaster, an extremely hard material, giving the illusion that it had been poured and set. In an interview of 1969, Bourgeois explained:

Some materials are fine for the pinning down of ideas, but they are not permanent, and they do not take a satisfactory surface. However, all the shapes have in common the fact that originally they were poured, and could be obtained only through that process. (The poured form is stretched from the inside and obeys the laws of gravity.) For the pouring to be expressed you must have an elastic container; eg hot wax poured into freezing water will assume a unique shape. Because the poured form is necessarily basically simple, it can without contradiction be given permanence in marble.[44]

These processes allowed Bourgeois to let go of some aspects of her control over the material, allowing it to take on its own 'formless' existence, just as Robert Morris had allowed his felt pieces to drop randomly (according to the laws of gravity) from wall to floor. But for Bourgeois, the materials were always closely associated with bodily, psychological and emotional states:

Content is a concern with the human body; its aspect, its changes, transformations, what it needs, wants and feels – its function. What it perceives and undergoes passively, what it performs. What it feels and what protects it – its habitat. All these states of being, perceiving and doing are expressed by processes that are familiar to us and that have to do with the treatment of materials, pouring, flowing, dripping, oozing out, setting, hardening, coagulating, thawing, expanding, contacting, and the voluntary aspects such as splitting away, advancing, collecting, letting go.[45]

Series of works using and repeating a rounded form, titled either *Cumul* or *Colonnata*, more clearly resemble body parts: multiple breasts or penises grouped together. The title *Cumul* comes from 'cumulus', the name of the clearly defined cotton-like clouds that in turn take their name from the Latin for 'heap' or 'pile'. These works are successfully ambiguous as both body and landscape. Bourgeois first made these shapes in a plaster sculpture that she titled *Avenza* 1968–9, after an area in Carrara, Italy, famous for its marble quarries. It is possible that she already had in mind its successive interpretation in marble in the form of *Cumul I* 1969 (fig.41). This pure white, carved piece sits on top of two large hunks of untreated wood that form its plinth and seem to throw into relief the highly crafted stone. In 1967 Bourgeois started to make trips to Italy in order to create works in marble and bronze. A number of major pieces, including *Cumul I* 1969, *Sleep II* 1967 and *Germinal* 1967, were made as a result of these trips.

Bourgeois's use of such traditional, crafted and durable materials may have seemed shocking following her employment of new materials like latex, and at a time when her work had been seen alongside the products of a younger generation of artists who were embracing the ephemeral and turning away from the monolithic, commodified work of art. For those who knew her work and had started to get to grips with her use of materials such as wax, latex, plaster

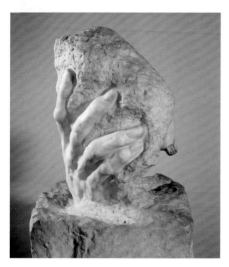

Auguste Rodin
THE HAND OF GOD c.1896 [42]
Marble, height 73.7
The Metropolitan Museum
of Art, New York

and plastic, the sudden turn to cast bronze and carved marble may have taken them by surprise. Undoubtedly, there were pragmatic reasons for this choice of medium. Latex and plaster are notoriously difficult to preserve in the long term. But Bourgeois's carved and cast pieces make a self-conscious virtue of the fact that they manage to set in stone such apparently liquid, organic, soft or bodily forms. It is no accident, therefore, that the artist chose to present the idea of softness in a work such as *End of Softness* 1967, which is cast in weighty, rigid and seductively shiny bronze. The contradiction of material and subject or form and content is precisely the appeal for Bourgeois. These works hold in tension such binary concepts as hard and soft, seductive and repulsive, formed and formless.

The use of marble and bronze also puts Bourgeois's works into a tradition of sculptural practice associated with masters such as Michelangelo, Bernini or Rodin, in which a seemingly impossible, fleshy form is rendered from stone. In the 1980s and 1990s Bourgeois produced a new series of marble pieces carved from pink stone (fig.43). Life-like hands, arms, breasts and other body parts appear from the rough block of stone at their base – in a similar manner to Rodin's iconic works such as *The Kiss* 1898 and *The Hand of God* c.1896 (fig.42), demonstrating the skill of the carver in replicating the look of smooth, supple flesh. Though Bourgeois worked on the carving and shaping of many of her marble pieces herself, she also used professional stonemasons, just as Rodin did. *Sleep II* 1967 (fig.44) is a single isolated form similar to those in the *Cumuls* or *Colonnatas*. Resembling a flaccid penis, slightly nodding in one direction, the shape was re-used and in fact doubled up to make the hanging bronze *Janus Fleuri* 1968 (fig.45). Bourgeois described *Janus Fleuri* in a statement from 1969: 'It is symmetrical, like a human body, and it has the scale of those various parts of the body to which it may, perhaps, refer: a double facial mask, two breasts, two knees. Its hung position indicates passivity, but its low slung mass expresses resistance and duration. It is perhaps a self-portrait – one of many.'[46]

Bourgeois made a number of works in the late 1960s that had the ability, like *Sleep II* and *Janus Fleuri*, to combine both masculine and feminine elements. Though she denied that her work was in any way 'erotic', the blatantly phallic *Fillette* 1968 (the title translates as 'Little Girl') – an oversized latex phallus suspended from a hook in the ceiling (fig.46) – and *Femme Couteau* (Knife Woman) 1969–70, a slim, horizontal blade of marble with clear female parts, both seem to merge the male and female, again complicating or denying these binary positions. Bourgeois was well-versed in psychoanalytic theory, and was aware – in Freudian terms – that adopting the phallus is seen as an attempt to make up for a lack, or to seize power. But beyond that, she was actually seeking a way to explore the vulnerability of both sexes: 'This marble sculpture – my *Femme Couteau* – embodies the polarity of woman, the destructive and the seductive . . . In the *Femme Couteau*, the woman turns into a blade, she is defensive. She identifies with the penis to defend herself . . . We are all vulnerable in some way, and we are all male-female.'[47]

Though Bourgeois stated on a number of occasions that her mother was a feminist, her own identification with the term and with the movement varied throughout her lifetime. Having lived to witness the impact of at least two different generations or 'waves' of feminist thought, theory and practice, Bourgeois arguably contributed most strongly to developments in feminist art theory through the consideration of her work some years after it was actually created. Her

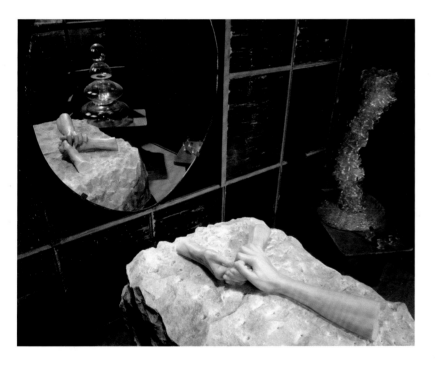

works from the 1960s have been a significant draw for academic, feminist-psychoanalytical readings since the 1990s. Bourgeois's sculptures provide a spatial analogy for the not-yet-fully formed subjectivity of an infant – this topic being most thoroughly expanded by Melanie Klein's psychoanalytic theories. As art historian Mignon Nixon has pointed out, Bourgeois had contemplated graduate study in the psychology of art with a view to the potential option of becoming a child therapist and was likely to have read Klein. Her understanding of psychoanalysis and her ability to tap into her own subconscious, coupled with her capacity to produce sculptures that truly challenge some of the dominant, phallocentric ways of looking at or thinking about art, have since marked Bourgeois out as a force to be reckoned with. The freedom and confidence she gained in her fifties enabled her to experiment with processes and materials in order to make new forms of the 'formless' and to give shape to an alternative, newly emerging subjectivity. These experiments are still being considered and discussed.

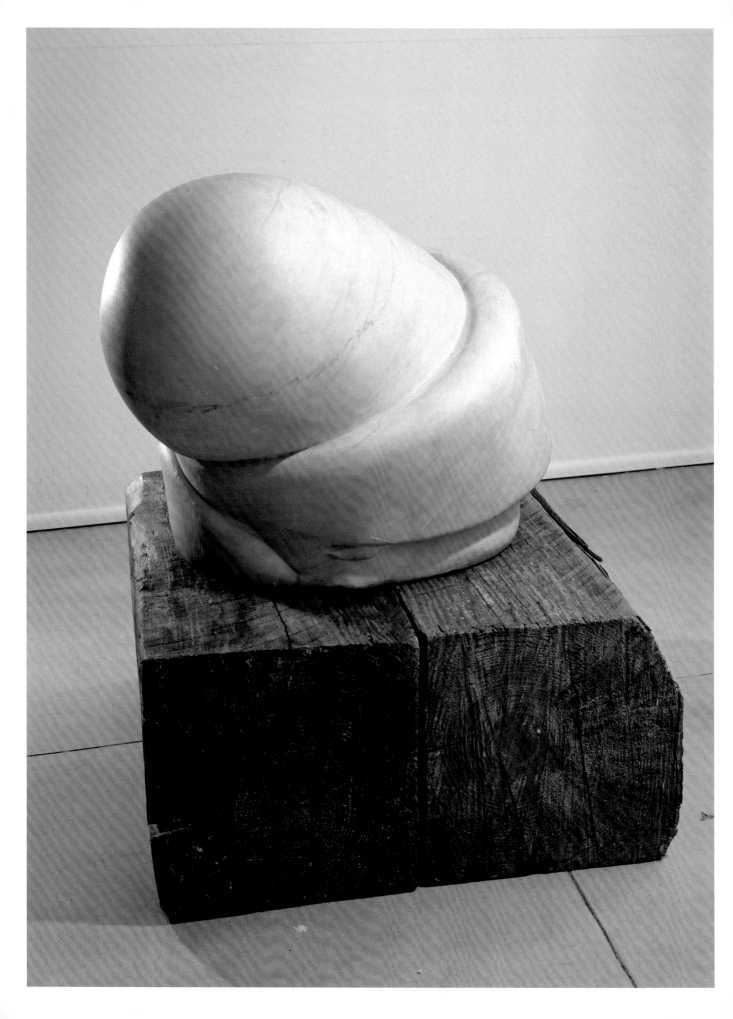

SLEEP II 1967 [44]
Marble 59.4 x 76.8 x 60.3;
two wooden timbers,
each 27.9 x 83.8 x 35.5

JANUS FLEURI 1968 [45]
Bronze with gold patina,
hanging piece 25.7 x 31.8 x 21.3

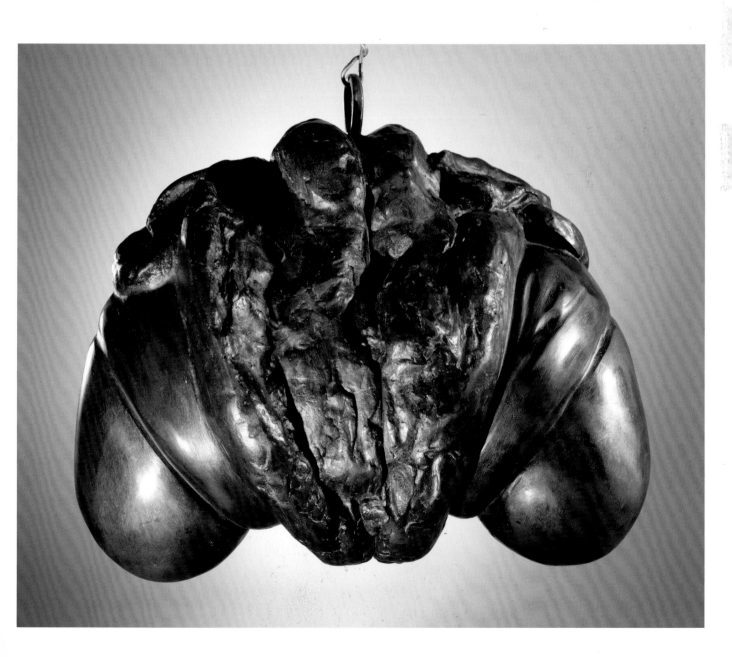

Fillette 1968 (fig.46) is one of Bourgeois's best-known works. This is partly due to the fact that it is her most literally phallic sculpture, and partly because it was immortalised by Robert Mapplethorpe's photographic portrait of the artist from 1982.

Mapplethorpe took a photograph of that sculpture, Fillette, *in which I'm holding it in my arms. Which means simply that from a sexual point of view I consider the masculine attributes to be extremely delicate; they're objects that the woman, thus myself, must protect. It's a very, very strong thing, because I was considering the masculine genital parts as attributes that I have to protect. Perhaps this is childish; you're asking me what I think but this is the origin of the word* Fillette. *The word 'fillette' is an extremely delicate thing that needs to be protected. And to displace these attributes onto something that is dear to me in fact, the attributes of my husband. It's very complicated.'*[48]

Male vulnerability is a theme that recurs in Bourgeois's later works, in particular the *Arch of Hysteria* 1993 (fig.49) (a contorted figure referring to the male hysteric as studied by the nineteenth-century French neurologist Jean-Martin Charcot), and the washy red drawing of a pregnant man *The Maternal Man* 2008 (fig.48). The title of *Fillette* serves as a clear indication that Bourgeois saw the object as both masculine and feminine. As in the hanging *Janus* works of the 1960s, both male and female sexual parts are combined and exposed. Art historian Rosalind Krauss has explored the piece in terms of Bataille's *informe*:

Fillette *is* informe *as Georges Bataille had defined it in the 1920s, meaning a collapse of the difference between those categorical oppositions on which meaning depends. Male versus female is the standard of such an opposition – perhaps the primary one.* Fillette *acts to blur this distinction as the vaginal opening at the foot of the shaft and between the two testicles forces male and female to merge.*[49]

Bourgeois also referred to *Fillette* as a 'little Louise'. It is at once herself, her husband and her child. She associated the sculpture with all those dear to her, those who needed her protection or love. Like the totemic fetish-objects that she created in the 1940s and 1950s, *Fillette* is something she may have carried around as a comforting presence. Mapplethorpe's photographs show her cradling the object like a baby.

The first version of *Fillette* was made in 1968 and is in the collection of the Museum of Modern Art, New York. In 1999, Bourgeois created a new work entitled *Fillette (Sweeter Version)* (fig.47). Both pieces are made of latex. While the original was first suspended from a sinister-looking meat-hook, which pierced the tip of the phallus, *Fillette (Sweeter Version)* hangs from a twisted wire and is smoother in appearance. Many of Bourgeois's works are made to hang from the ceiling, suspended in space. Physically, this enables the object to twist and turn, clearly pulled by the force of gravity, and to be easily viewed from different angles. Psychologically, hanging refers to a state of uncertainty (to be left hanging), or of being blocked or stuck with past traumas (hanging on), or of persistent survival (hanging by a thread). In Bourgeois's words: 'horizontality is a desire to give up, to sleep. Verticality is an attempt to escape. Hanging and floating are states of ambivalence.'[50]

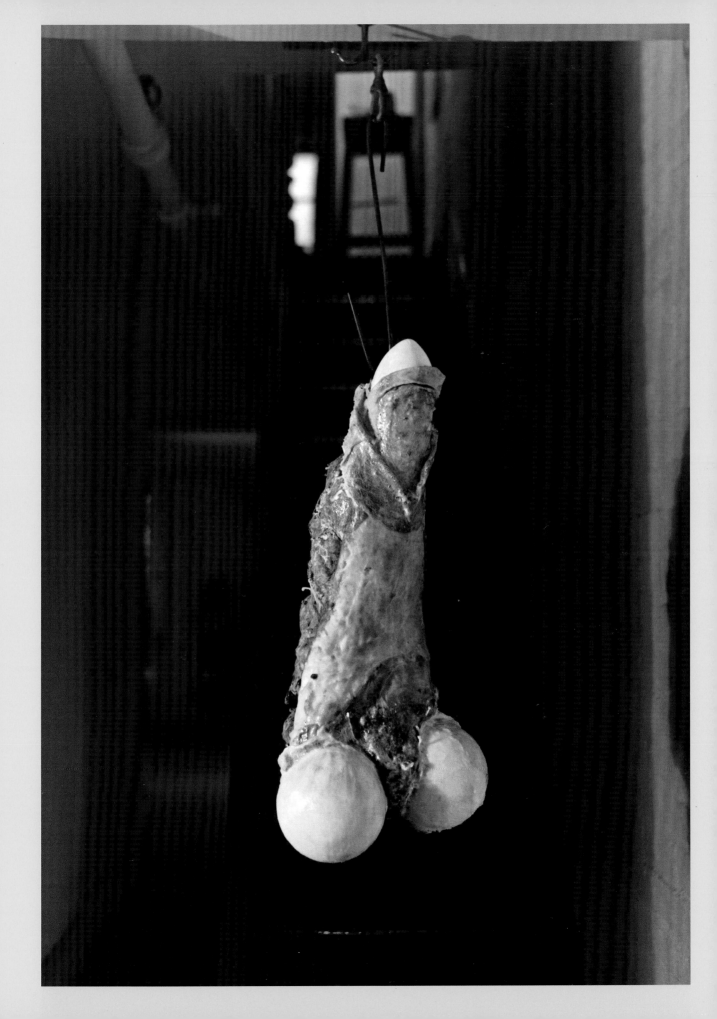

Bourgeois spoke about her memories of her father's attic, which was used to store furniture to be repaired: 'You would look up and see these armchairs hanging in very good order. The floor was bare. It was quite impressive. This is the origin of a lot of hanging pieces.'[51] *The Quartered One* 1964–5 combines the phallic shape of *Fillette* with the concealed, nest-like spaces of the *Lairs*. Both works have a carnal aspect, like pieces of meat being hung.

Fillette was included in the 1994 exhibition *Bad Girls*,[52] along with Linda Benglis's 1974 advertisement photograph that appeared in the pages of *Artforum* showing Benglis naked and holding an oversized dildo between her legs. Both artists were seen by the exhibition's curators as iconic mother figures for a later generation of feminist artists. But whilst Benglis was clearly setting out to shock with one bold image, Bourgeois's phallic sculpture arose from the development of her practice; perhaps only later did she stand back and reflect on the scandalous object with a wry smile.

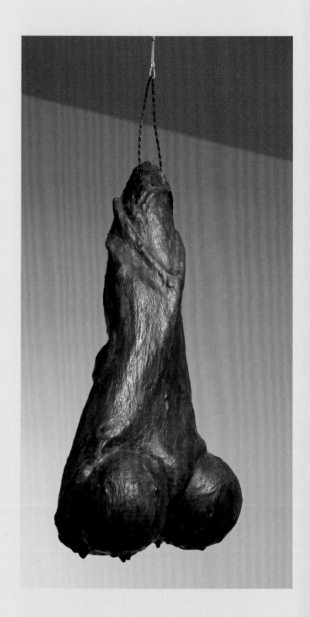

ARCH OF HYSTERIA 1993 [49]
Bronze, polished patina, hanging piece
83.8 x 101.6 x 58.4

THE DESTRUCTION OF THE
FATHER 1974 [50]
Plaster, latex, wood, fabric and
red light 237.8 x 362.3 x 248.7

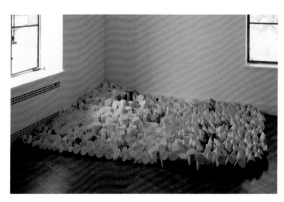

NUMBER SEVENTY-TWO
(THE NO MARCH) 1972 [51]
Marble and travertine
50.8 x 304.8 x 274.3

4

STAGING A TENDER TRAP

Each Cell deals with the pleasure of the voyeur, the thrill of looking and being looked at. The Cells either attract or repulse each other. There is this urge to integrate, merge, or disintegrate.[53]

Bourgeois was most clearly involved with the feminist movement in the 1970s, when she took part in eighteen 'protest' exhibitions, including *13 Women Artists*, organised by the New York Women's Ad-Hoc Committee, and the *East Coast Women's Invitation Exhibition* at Philadelphia Museum. She won a prize for achievement in the visual arts from the Women's Caucus for the Arts; responded to various interviews and questionnaires about the experience and treatment of women in the art world; and in 1979 a feminist dinner party was held in her honour. Though the second wave feminists' rallying cry 'the personal as political' was surely nothing new to Bourgeois, she was undoubtedly more active in her support for and alliance with feminism at this time than during any other period of her life. Bourgeois had begun to find her followers and they looked up to her as a senior figure. As Judith Russi Kirschner wrote in a review of 1981: 'The work's remarkable originality and boldness is the result of Bourgeois's 40 year confrontation with primal female nature and the myth of creation ... Are we at last the audience competent to receive Louise Bourgeois? ... Are we the audience she has been waiting for?'[54]

The 1970s were highly active years for Bourgeois. After the death of Goldwater in 1973, she took on commissions and teaching posts to support herself. In 1977 she received an honorary degree from Yale University. As teacher and mentor for a new generation of artists she couldn't help but absorb the energies and trends of the time, and this may have been a contributing factor leading to the creation of a number of significant works that were more political, environmental, theatrical or performative in nature.

Number Seventy-two (The No March) 1972 (fig.51) appears to reflect in sculptural form the particular collective consciousness of the time, to which Bourgeois was attuned. Assembling a mass of individual cylindrical marble shapes, the work extends her methods in creating multi-part pieces such as *One and Others*, *The Blind Leading the Blind* or *Cumul*. *Number Seventy-two (The No March)* combines this modular arrangement with a renewed concern for the work's placement, echoing Bourgeois's earlier interest in the relative positions and interaction of her *Personages* in her shows of the 1950s. First installed at the Whitney Biennial in 1973, the piece was acquired by the Storm King Art Centre in Mountainville, New York, where it was placed outdoors beneath a tree. In this green location it took on a more organic appearance, removing somewhat the connotations of combined political resistance.

Bourgeois's most arresting work from this period, *The Destruction of the Father* 1974 (fig.50) is a tableau arrangement of large bulbous latex forms set within a dark, cloth-lined box or recess and lit so that it emits an eerie red glow, like the embers of an oversized fireplace. The viewer is only able to approach the dramatic set-up from the front, enforcing the sense of a kind of staged theatricality. The artist described in quite literal, unequivocal terms the scenario she had laid out:

The piece is basically a table, the awful terrifying family dinner table headed by the father who sits and gloats. And the others, the wife, the children, what can they do? They sit there, in silence. The mother, of course, tries to satisfy the tyrant, her husband. The children are full of exasperation . . . My father would get nervous looking at us, and he would explain to all of us what a great man he was. So, in exasperation, we grabbed the man, threw him on the table, dismembered him and proceeded to devour him.[55]

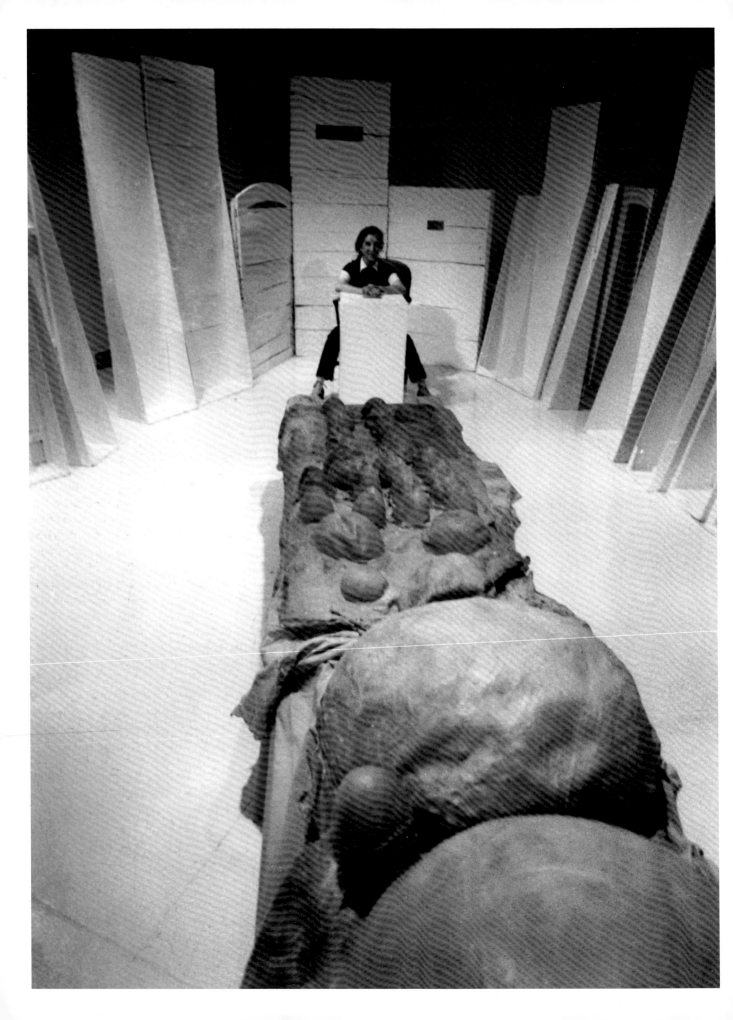

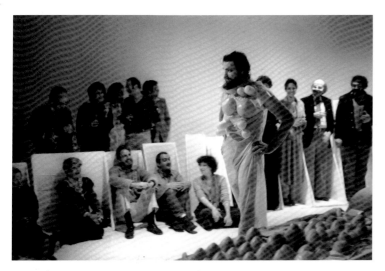

Louise with CONFRONTATION
1978 [52]
Photo by Peter Moore © Estate of
Peter Moore / VAGA, NYC

A BANQUET / A FASHION SHOW OF
BODY PARTS 1978 [53]
Photo by Peter Moore © Estate of
Peter Moore / VAGA, NYC

Louise Bourgeois on steps of her
New York home in 1975 wearing the
latex sculpture AVENZA that became
part of CONFRONTATION 1978 [54]
Photo by Peter Moore © Estate of
Peter Moore / VAGA, NYC

Her cannabalistic fantasy springs from a childhood memory that she revealed in 1992: 'Once when we were sitting together at the dining table, I took white bread, mixed it with spit, and molded a figure of my father. When the figure was done, I started cutting off the limbs with a knife. I see this as my first sculptural solution.'[56]

These revelatory statements came some time after *The Destruction of the Father* was actually made. Bourgeois first disclosed the story of her childhood traumas to the wider world at the time of her retrospective exhibition at the Museum of Modern Art, New York, in 1982, when she put together a slide show of photographs from her past, and published a project called 'Child Abuse' in the December 1982 issue of *Artforum* magazine. Though her work had always reflected the concerns of her personal life – and, since the 1960s, her interest in psychoanalysis – the postmodern artistic climate of the early 1980s was one in which the personal and narrative were seen as important elements in art practice and Bourgeois, by now in her seventies, could finally speak out. This first major retrospective introduced her work to a broader audience.

An extended version of the dining table in *The Destruction of the Father* appeared, this time in the form of a long stretcher-table, in a large piece called *Confrontation* that was shown at the Hamilton Gallery in 1978 (fig.52). *Confrontation* could be described as an installation, filling the gallery space. In her catalogue essay for the 1982 MoMA retrospective, curator Deborah Wye referred to this piece as 'Theatrical to its very essence.'[57] Variously shaped white-painted wooden boxes stand like sentinels circling the table with its latex forms, looking like the aftermath of some kind of ritualistic event. The boxes keep the viewer at a distance from the scene inside. As Wye remarked, 'this is a private event and the viewer is only a spectator'.[58] The work became something entirely different, however, when

Bourgeois staged a performance during the exhibition, titled *A Banquet / A Fashion Show of Body Parts*. This parodic runway show took place on the inside of the circle, Bourgeois having persuaded a number of friends to don costumes that sprouted rounded, latex forms similar to those on the table (fig.53). Among the 'models' were art-historian Gert Schiff and painter Robbie Tillotson.

Bourgeois's performance combined elements of the ridiculous with a sense of something darker lurking beneath. One of the performers, Susan Cooper, sang a lament, 'She Abandoned Me', written by Bourgeois in reference to her mother. Bourgeois explained, 'But you see, it was all a joke . . . a comment on the sexes because they are so mixed today. What more is there to say? The humour is black. Despair is always black.'[59]

Bourgeois staged her first performance at a time when New York-based feminist artists such as Hannah Wilke, Anna Mendieta and Carolee Schneeman had been using their own bodies in performances and as the subject of photographs in order to question cultural assumptions about femininity and to seize control of their representation. Though Bourgeois did not use her own body directly, her dalliance with the medium of performance in *A Banquet / A Fashion Show of Body Parts* may be seen to have demonstrated her interest in the debates about voyeurism, gender and desire that were hot issues of the time. A photograph from 1975 shows Bourgeois standing in the street in front of her home wearing the latex sculpture *Avenza* 1968–9 as a costume (fig.54). The fat, bulbous covering resembles a turtle shell or some other kind of organic body armour – something protective inside which one could easily curl up in order to become invisible. The photograph may have been set up as a joke, or it may have been a way to present the image of the artist and her work for publicity purposes. But whatever the motivation,

Interior view of Louise Bourgeois's
Brooklyn studio in 1982 [55]
Photo © by Peter Moore

Bourgeois's decision literally to wear her sculpture, to climb inside it and to present it this way in a photograph, transforms it from an inert object into one that is performative.

Though her work developed in a different direction throughout the 1980s, Bourgeois did stage one other well-documented performance, titled *She Lost It*, in collaboration with The Fabric Workshop in Philadelphia in 1992. A long strip of cotton gauze was printed with the words from a poem that Bourgeois had written in 1947. A performer who had been tightly wrapped in the gauze like a mummy was slowly unwound whilst the fabric was transferred onto a couple at the other side of the stage, passing the words from one side to the other. Bourgeois explained, 'The story of separation becomes an act of binding the couple together.'[60]

Bourgeois's interest in fashion and textiles and the function of outer-garments to adorn, protect, or indeed to parody the body had been with her for most of her life. It seems appropriate, therefore, that when she decided to find a new studio space in 1980 in which to store her ever-growing body of work and to create more on a larger scale, she bought a loft in a former garment factory in Brooklyn (fig.55). The large, open space was lit by fluorescent bulbs set out across the ceiling in the spots where each seamstress was positioned. After her retrospective exhibition at MoMA in 1982, Bourgeois attracted a new level of recognition as an artist. Her resources had also expanded in line with her success. In the early 1980s she employed an assistant, Jerry Gorovoy, who worked with her closely, becoming her trusted advocate and manager of her affairs, as well as her close friend and carer.

Following a visit to the Brooklyn studio, Christiane Meyer-Thoss described Bourgeois's space as 'a labyrinthine garden'. She compared the artist to an animal, shaping its habitat:

Every morning at the same time Bourgeois enters her space, her forgotten sky, and makes the rounds, rearranging as she goes through the stacks and assemblages of ribbons, wooden blocks, metal tubing. As time passes, she wears paths through the studio like those animals take to flee through underbrush. After a while, these escape routes, as changeable as the light, show where Bourgeois is going. She is only interested in fresh trails.[61]

Bourgeois herself said: 'The labyrinth has many meanings for me. It can hide me and no one can find me, and I can go out without anyone noticing. If I like my visitor the labyrinth becomes a means of seduction, what I call a tender trap.'

The Brooklyn studio enabled Bourgeois to see and to reflect upon works from her 'back catalogue', feeding her urge to rework and reintroduce themes and fragments from earlier years. It also enabled her to make larger, more environmental or architectural pieces. In the Greek myth, Ariadne provides the thread to enable Theseus to find his way out of the Labyrinth. Bourgeois's works themselves and her statements about them provide us with clues as to why, during this period of her life, she may have been especially interested in staging scenarios of entrapment, of expanding her sculptural lairs to a more architectural scale that implicates the viewer, forcing one to become caught up in her tangled webs of meaning.

Articulated Lair 1986 (fig.56) is one of a small number of works in which the viewer is actually able to step inside the enclosed space that Bourgeois has created. Like an expanded version of the white wooden boxes encircling the stretcher table in *Confrontation*, the *Articulated Lair* encloses an area of floor space inside a wall made up of tall, hinged folding screens in a concertina shape with two doors: an entrance and an exit. The piece is flexible and can be expanded or contracted. Inside is a low stool and hanging from the

ARTICULATED LAIR 1986 [56]
Painted steel, rubber and stool
335.2 x 335.2 x 335.2
The Museum of Modern Art,
New York

walls is a group of black rubber objects reminiscent of the 'packages' from *Woman with Packages* 1949, or *Quarantania* 1947–53.

Bourgeois has described her *Articulated Lair* as a place of isolation and loneliness:

Articulated Lair is a closed environment eleven feet high. It is a circle with two openings. It is a 'lair'. . . Inside there is just one tiny stool. Nobody's around. It is a place to face the fact that there is nothing – nothing to expect. You can sit there. It is not unsafe, but it is empty. Nobody can hurt you. You are not even afraid of being hurt. You are afraid of being alone. Why? Because you have chased everybody out. You are alone by your own doing. It is total loneliness. It is like the set for the No Exit *of Jean-Paul Satre. Jean-Paul Satre said in* No Exit: *'L'enfer c'est les autres' ('Hell is other people'). I say Hell is the absence of others – that's Hell.*[62]

The scenario she describes is like that of a sulking child who shuts herself in a closet and then realises she is lonely in her self-imposed confinement. Though the visitor may enter the lair, it is in fact Bourgeois herself who feels the loneliness as described above, the result of shutting others out in order to protect herself. At a time when her success was making her more visible on the international 'stage', when she had revealed the traumas of her childhood and her deepest motivations, Bourgeois was anxious to put the barriers back up. She became increasingly agoraphobic, and in 1993 declined to attend the opening of the Venice Biennale when she represented the United States at the American Pavilion. In an interview of 1992 she voiced her fear, saying: 'I have an intense need for privacy – an intense fear of exchange with other people. All I want is to take refuge.'[63]

Articulated Lair, along with two other works, *No Escape* 1989 and *No Exit* 1989, have been described as the precursors for Bourgeois's series of *Cells*, room-like structures that she developed throughout the 1990s in which the themes of enclosure and confine-

ment are continued. In 1992 Bourgeois created two of her most powerful and well-known *Cells*: *Precious Liquids* (figs.57, 58) and *Cell (Arch of Hysteria)*. Both works received critical acclaim when they were included in the year's most important international exhibitions, the former at Documenta and the latter at the Venice Biennale.

Bourgeois had previously made use of the cedar wood from New York's iconic roof-inhabiting water towers in elements of her *Personages* in the 1950s. Now, the expansive space of her Brooklyn studio, the trajectory of her recent work, the aid of her assistants, and the artistic climate of the 1990s in which installation art was becoming the *mode du jour* may have all factored in Bourgeois's decision to use the whole outer structure of a salvaged water tower in which to create her own peculiar environment for *Precious Liquids*. Running around the outside of the hefty, cylindrical wooden structure is a text welded in steel stating 'Art is a Guaranty of Sanity.' Declaring its cathartic stance on the outside, the tower's interior – visually accessible via a doorway cut into its wall – brings together a group of intriguing objects. Glass vials are attached to metal branches on four tall rusty poles that hover on either side of a bed frame. Bourgeois said that *Precious Liquids* relates to girl who is coming of age. The liquids present in the title, and implied by the glass vessels, relate to the release of emotions. The glass: 'becomes a metaphor for muscles. It represents the subtlety of emotions, the organic yet unstable nature of mechanism. When the body's muscles relax and un-tense, a liquid is produced. Intense emotions become a material liquid, triggering the secretion of precious liquids.'[64]

Opposite the bed is an over-sized coat, hanging up on the curved wooden wall. The coat is a hiding place for a little dress that hangs inside it. Bourgeois had

PRECIOUS LIQUIDS 1992 [57]
Wood, metal, glass, alabaster,
cloth and water 425.5 x 445.1 x 445.1
Musée national d'art modern,
Centre Georges Pompidou, Paris

Detail of PRECIOUS LIQUIDS
1992 [58]

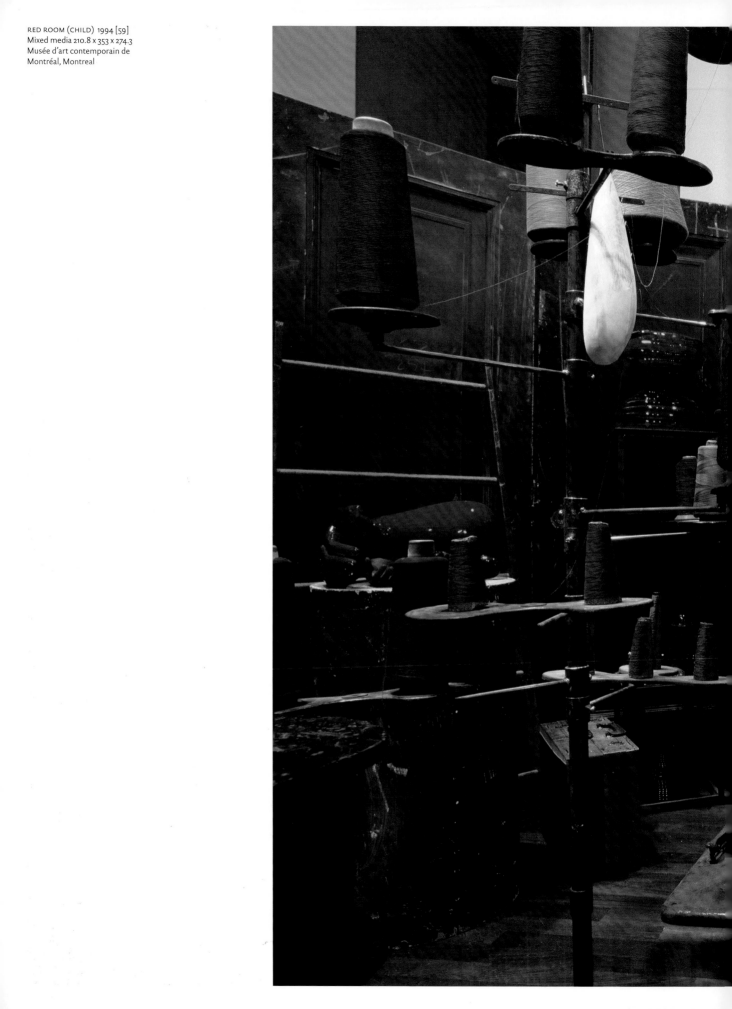

PASSAGE DANGEREUX 1997, detail [60]
Mixed media 264 x 355.5 x 876.5
Collection Ursula Hauser, Switzerland

voyeurism and the wish to escape it at the forefront of her mind when she offered the following explanation:

The coat represents, you might say, the tragedy of the voyeur ... He refuses to get out of the place. He's not a casual presence. Inside the flasher's coat there is a little white dress – the dress of, say, a twelve-year-old girl. That little female presence probably has to do with certain memories of mine. Actually, the person who enters the piece should open the coat and see what is in there. On the little dress there's the embroidery 'mercy merci'... at that point we are done with the flasher. He's a compulsive creature ... In Precious Liquids the girl, for her own ... sanity – has to come to terms with the flasher. So she closes her eyes, refuses to see him, and turns the matter around by taking refuge in his coat. This is a metaphor for the artist. If the artist cannot deal with everyday reality, the artist will retreat into his or her unconscious and feel at ease there, limited as it is – and frightening sometimes.[65]

Indeed, the *Cells* appear in many ways to represent the private contents of the artist's head, her conscious and unconscious thoughts, emotions, anxieties and fears. The word 'cell' is used to refer to both an enclosed room, as in prison cell, and the most basic elements of plant and animal life, like the cells of the body. Bourgeois uses either salvaged doors or cage-like metal grids to create and define her sculptural spaces. *Passage Dangereux* 1997 (fig.60), the largest of these works, takes the form of a corridor with several rooms, encompassing all manner of dusty old objects, including hanging chairs that for Bourgeois recalled the chairs her father stored as part of his restoration business. A tapestry hangs in one of the smaller spaces. Tapestry fragments also figure prominently in the round caged cell that sits beneath the protective legs of one of Bourgeois's iconic spiders. Other caged cells include *Cell (Eyes and Mirrors)* 1989–93, *Cell (Choisy)* 1990–3 and *Cell (You'd Better Grow Up)* 1993.

With the pair of cells titled *Red Room (Parents)* 1994 and *Red Room (Child)* 1994 (figs.59, 61), the viewer first encounters two guarded spiral-shaped structures made from a succession of dark scuffed-up wood-panelled doors. Peeping through the gaps, one is immediately forced into the position of voyeur trying to see and make sense of the glimpses of scarlet red and bright blue from the objects set up inside. Reaching the 'doorway' of each of the red rooms, one is held back from entering by a simple barrier. There is a feeling of coming across someone else's domestic realm, a private living space and a simultaneous, uncanny sense of the places we have been in the past but cannot quite locate in space or time. One of the best views of the child's room can be seen through a broken glass panel in a protective door, on which is the remains of a sign in black lettering that reads 'RIVAT', the P and the E having been scratched away. The child's room contains an array of intriguing objects: spools of red and blue thread; waxy casts of joined hands; some spiralling pieces of red glass; a jar of pennies; an old suitcase; a medicine cabinet; a bookcase, with further objects including a pair of white mittens with the words *moi* and *toi* knitted in red yarn ... it's difficult to remember all of the objects contained in the small space when one walks away, suggesting that Bourgeois may be playing a memory game. Many of these items relate to her childhood and her adult interpretations of it. They represent some of the objects, as well as the relationships, she had made, accumulated, broken or fixed over time. But there is something more universally evocative about these rooms. One does not necessarily need to know Bourgeois's own stories to respond to the scene that has been set out. In the case of the parents' room, the scenario of wandering into an adult bedchamber has obvious Freudian implications relating to the 'primal scene', when a

RED ROOM (PARENTS) 1994 [61]
Mixed media 247.7 x 426.7 x 424.2
Collection Ursula Hauser, Switzerland

UNTITLED 1950 [62]
Ink and charcoal on paper
35.6 x 27.9

child first 'witnesses' (subconsciously, if not literally) the parents having intercourse. This room is more ordered than the chaotic child's room. The bed has a shiny red rubber covering, and a small cushion in the centre of the pillows is embroidered with the words *je t'aime*. At the foot of the bed are a child's train set and a xylophone case. Hanging up on the wall is a large pink tear-drop shaped sculpture, reminiscent of Salvador Dalí's melting clocks or the hanging black shapes in *Articulated Lair*. The atmosphere is one of foreboding eroticism. All of this is most clearly visible to the viewer from a large oval mirror, positioned so that the viewer is also forced to encounter his or her own reflection.

A number of *Cells* such as *Cell (Eyes and Mirrors)* (fig.63), *Cell (You'd Better Grow Up)* and *Cell (Twelve Oval Mirrors)* 1998 have large, pivoting mirrors incorporated into their cage-like exteriors. Bourgeois's mirrors are usually enlarged versions of the clinical round or oval, metal-framed mirrors mounted on a stand that one might find in a bathroom, designed for detailed self-scrutiny. Most of Bourgeois's *Cells* appear to act as sculptural, claustrophobic and surprisingly restricted literal and/or metaphorical mirrors revealing glimpses of Bourgeois's inner-self. Just as the mirror in *Red Room (Parents)* both reflects the elements inside the room and blocks the view, confronting the viewer with his or her own reflection, the *Cells* epitomise Bourgeois's ability to simultaneously expose and protect herself through her works. '*Mise-en-scène*' is a cinematic or theatrical term referring to the tone, meaning and narrative information made visible to the viewer through set design and other visual elements. Often, a character's state of mind is represented through these devices. Following Bourgeois's analogy of the flasher's overcoat in *Precious Liquids* being like the unconscious

in which she wishes to hide, it would be possible to read her *Cells* – and the stories she presented to explain and support them – as 'staged' versions of her memories and realities, where Bourgeois the director, the 'stager' of her own *mise-en-scène*, is revealing insights that she is happy to offer up and yet also to hide behind. At the start of a television interview from 1993 Bourgeois creates drama for the camera when she holds up a sign saying 'NO TRESPASSING' in front of her face. Later, she holds up a mirror when she has had enough of the interviewer's probing questions. Many of the *Cells* take the same approach, holding up a mirror, as if to say, 'Make what you will of this', 'Work it out for yourself', or 'See who or what you recognise here.'

In a small ink and charcoal drawing dating from 1950, Bourgeois presented a little face peeping out from behind two long curtains (fig.62). When asked about this drawing, she replied, 'That's fear. The person isn't watching or spying, it's someone hiding. The curtain is like the shutters in the South of France, which keep the sun out, but you're hidden from view.'[66] Like an actor who takes a quick look at the audience before the curtain rises to reveal the stage set, Bourgeois's little character is in the position of power, hiding, yet checking what is out there, who the audience is and how they will be seen. Similarly, at a time when Bourgeois was gaining great exposure as an artist, when her family secrets had been revealed and her work was featured at the largest international exhibitions, she needed to create something to hide behind in order to maintain her sense of power or control. The *Cells* play on our voyeurism as viewers and force us to confront our own baggage along with Bourgeois's accumulated possessions. They are teasing, seductive, evocative, giving enough of themselves away yet always holding something back from view.

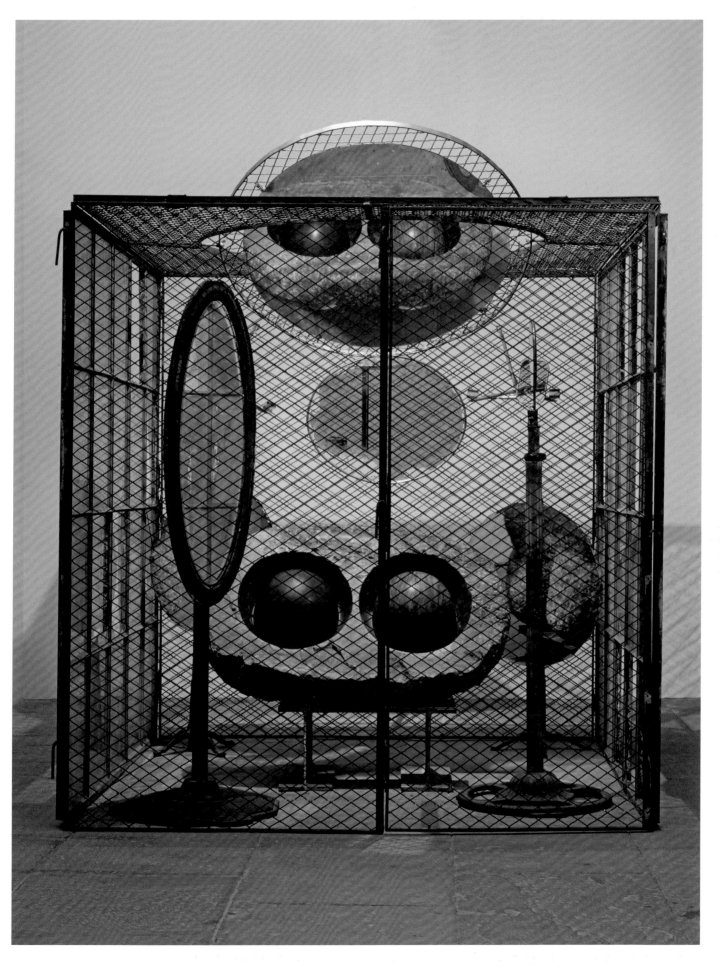

At the end of the twentieth century Bourgeois completed a number of significant sculptural commissions. This enabled her to extend her practice, working on a larger scale and responding to particular contexts. The first artist to be commissioned to fill Tate Modern's vast Turbine Hall in 2000, Bourgeois created her widely recognised, giant spider *Maman* 1999 along with three intimidating welded-steel towers titled *I Do, I Undo, I Redo.* Speaking about this title, Bourgeois explained that, 'I DO is an active state . . . The UNDO is the unravelling . . . The REDO means that a solution is found to the problem . . . the reparation and reconciliation have been achieved.'[67] The spider is a creature that Bourgeois associated with this ability to 'redo', or to repair: 'I came from a family of repairers. The spider is a repairer. If you bash into the web of a spider, she doesn't get mad. She weaves and she repairs it.'[68]

Maman is a huge steel structure, the legs spanning nearly nine metres. The spider holds her marble eggs in a sac that is protected below her abdomen (fig.65). A patchwork of steel pieces welded together forms each spindly leg, narrowing to a point where they meet the ground. Bourgeois's fascination with spiders has been in evidence since the 1940s, when she made the drawing *Spider* 1947 (fig.64). She even compared the act of drawing itself to the industrious making of a spider's web: 'What is a drawing? It is a secretion, like a thread in a spider's web . . . It is a knitting, a spiral, a spider web and other significant organizations of space.'[69] In the 1990s, spiders became a major theme in Bourgeois's work. They hover menacingly in corners or on walls, they squat protectively over her caged *Cells*, and they appear in several series of drawings and etchings.

The English name for the eight-legged creature is derived from 'spinder', one who spins a thread. Spiders loom large in myth and symbolism. In Greek mythology, Arachne is turned into a spider by the goddess Minerva, whom she challenges with her skills as a weaver. Aside from their ability to spin a thread and weave a web, spiders are known as predatory creatures and the female of the species is particularly greedy, sometimes eating the male after mating. Arachnaphobics often say that they are alarmed by the fast-paced scuttling motion of the spider, but the psychological associations may run deeper. Primo Levi explained the fear of spiders in *Other People's Trades* (1985):

The spider is the enemy-mother who envelops and encompasses, who wants to make us re-enter the womb from which we have issued, bind us tightly and take us back to the impotence of infancy, subject us again to her power; and there are those who remember that in all languages the spider's name is feminine, that the larger and more beautiful webs are those of the female spiders.[70]

But for Bourgeois, this image of the smothering, predatory or overprotective mother does not entirely match her own image of *Maman*, the industrious mother/spider she made to represent her own mother. In 1995 Bourgeois wrote her 'Ode à ma mère' (Ode to my Mother) a poem that reveals her motivations and her irritations at being caught in a web of her own making:

The friend (the spider – why the spider?) *because my best friend was my mother and she was deliberate, clever, patient, soothing, reasonable, dainty, subtle, indispensable, neat, and useful as an araignée. She could*

SPIDER 1947 [64]
Ink and charcoal on tan paper 29.2 x 22.2
Private collection

Overleaf MAMAN 1999 [65]
Bronze, stainless steel and marble 927.1 x 891.5 x 1023.6
Installed at the Wanås Foundation in Knislinge,
Sweden in 2007
Private collection, courtesy Cheim & Read, New York

also defend herself, and me, by refusing to answer 'stupid', inquisitive, embarrassing, personal questions.

I shall never tire of representing her.

I want to: eat, sleep, argue, hurt, destroy...

Why do you?

My reasons belong exclusively to me.

The treatment of Fear.

To my taste, the spider is a little bit too fastidious.

There is a very French, fiddly, overly rational, 'tricoteuse'

Side to her (Xavier Tricot), with her ever more precise and

Delicate invisible mending; she never tires of splitting hairs.

This endless analysis is exhausting, and visually it can be reductive.

It makes me want to rush out onto the street and fill my lungs with air.

Analyses without end, questions within questions – *mincing away.*

For once, this spider admits to being tired. She leans against the wall (see the prostitute who eyes her clients from the shadow of the doorway, against the door of the years).

To analyze to mince away is one thing but to make a decision is something else (a choice, a judgement of value).

Caught in a web of fear.

The spider's web.

The deprived woman.[71]

CELL (CLOTHES) 1996 [67]
Wood, glass, fabric, rubber and
mixed media 210.8 x 441.9 x 365.7
Private collection

5

STITCHED, STUFFED AND STRETCHED

You can retell your life and remember your life by the shape, weight, color and smell of those clothes in your closet. They are like the weather, the ocean – changing all the time.[72]

Marking the start of a decade in which Bourgeois created a variety of arresting works using textiles, *Cell (Clothes)* 1996 (fig.67) brings together a small selection of old garments that were once worn by the artist. The mostly monochromatic stockings, bloomers, skirts and dresses hang from wires or wooden clothes pegs within their dimly lit enclosure, giving this cell the appearance of a somewhat sinister laundry room, seedy brothel or eccentric attic. In the same year, Bourgeois created a series of works using steel poles with branch-like attachments from which the variously misshapen items of vintage clothing hang, sometimes alongside stitched and stuffed sculptures resembling bodies or drooping sacks. In two works, *Untitled* 1996 and *Pink Days and Blue Days* 1997 (fig.66) floaty, flesh-coloured slips, undergarments and other decorative, feminine items hang from hefty old bones that appear to stand in for coat hangers. These pieces bring to mind Bourgeois's proclamation that her later work is 'the art of hanging in there'. Feminist art historians Griselda Pollock and Linda Nochlin have both considered these works in some depth and argued that the juxtaposition of feminine, sexy clothing with the bare old bones acts as a shocking reminder of the ageing body, thus revealing Bourgeois's attempts to come to terms with her past through her presentation of the garments she wore as daughter, young woman, wife and mother, and to address her situation as an ageing, yet still powerful artist. Bourgeois herself said: 'Clothing is also an exercise of memory. It makes me explore the past: how did I feel when I wore that. They are like signposts in the search for the past.'[73]

On the steel base of the untitled piece, the following words can be read:

Seamstress

Mistress

Distress

Stress

For those in the know about Bourgeois's childhood trauma, there is the immediate association with her mother (the seamstress), Sadie (the mistress) and the resulting emotions in the young Louise (distress, stress). But in a wider sense, these words may also apply to the roles played by a young woman – worker, lover – which can be worn like clothing, hiding (or revealing) the emotions she may be carrying underneath. Perhaps the ageing artist was attempting to show that although she had cast off the glad-rags of her youth, what lies beneath – like the weighty bones – is made of sterner stuff. Interestingly, the words 'distress' and 'stress' are often applied to textiles themselves or items of furniture, particularly in describing a state of wear and tear. To 'distress' an object is to give it the appearance of age, as may be necessary in the repair of tapestries so that newly woven areas blend with the larger piece. It may be the seamstress's job to reverse the ageing process, or equally, to accelerate it.

Given Bourgeois's family background, it is no surprise that the processes employed in the restoration of tapestries – spinning, weaving, dyeing, stitching, darning – all left their mark on the dense metaphorical tapestry of her childhood imagination, resurfacing like coloured threads within her adult artistic career. A drawing from 1943 with the title *Skeins* shows two looped and coiled skeins of yarn with smiling human faces (fig.70). Needles and pins are stabbed into the small wax and wood *Femme Pieu* (Woman Pile) pieces that she made around 1970. In the *Cells*, statements are embroidered on pillow cases, dresses and coats. In

SEAMSTRESS MISTRESS
DISTRESS STRESS 1997 [68]
Ink on paper 29.2 x 29.8
Private collection

IN RESPITE 1993 [69]
Steel, thread and rubber
328.9 x 81.2 x 71.1
Private collection

Seamstress
mistress
Distress
stress

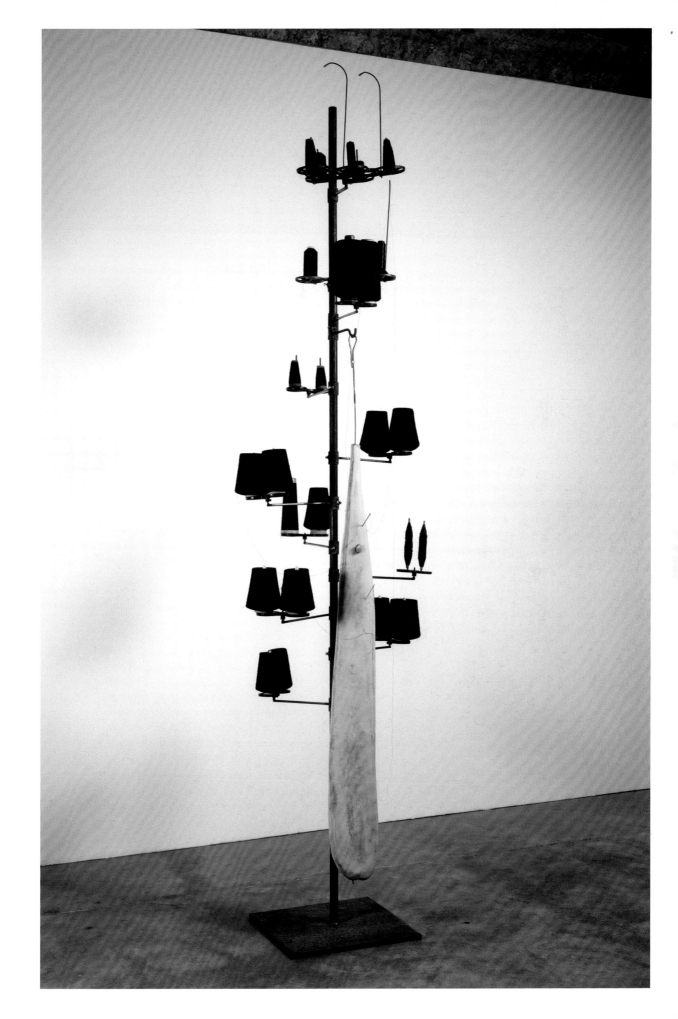

SKEINS 1943 [70]
Ink on grey paper 30.4 x 22.8
Collection of Michael and Joan Salke,
Boston, Massachusetts

Man Ray
L'ENIGME D'ISIDORE DUCASSE 1920,
remade 1972 [71]
Sewing machine, wool and string
35.5 x 60.5 x 33.5
Tate

freestanding works from 1993 titled *In Respite* (fig.69) and *Sutures*, spools of thread are displayed on branching upright poles, and threaded sewing needles are stuck like acupuncture instruments into drooping, pendulous rubber shapes. A similar structure can be seen in *Red Room (Parents)* 1994. In other works, oversized needles curve out from steel bases in a phallic manner, threading in a variety of materials like untreated flax, as in *Needle* 1992. Bourgeois explained: 'When I was growing up, all the women in my house used needles. I always had a fascination with the needle, the magic power of the needle. The needle is used to repair the damage. It's a claim to forgiveness. It is never aggressive, it is not a pin.'[74]

So the needle is associated with power, for Bourgeois, but also with reparation. Writer Paulo Herkenhoff suggests that:

The needle, then, represents Bourgeois's phenomeno-logical urge to join things together tightly and to form from within a diagram of her own existential condition and fear of separation and abandonment ... But to repair is to reconcile with an object, and this is not only symbolic of Bourgeois's psychological need to be reconciled with her past, but also connects her to the needle of her mother's workshop.[75]

Taking off from her use of salvaged items of clothing as 'found' objects, Bourgeois produced an extraordinary body of soft sculpture in her later years, making use of the trunks full of textiles and linens that she accumulated and kept for decades. To create these works, she went one step further. With the regular help of a seamstress, she unashamedly cut, stitched and stuffed a variety of fabrics to create both figurative and abstract sculptures from a medium so apparently unsuited to three-dimensional, sculptural use. Perhaps this was her last act of rebellion against the meticulous, reverential skill of her mother.

Though Bourgeois's works from the 1960s explore the idea of softness and the ability of a sculpture to be simultaneously soft and hard, and despite the fact that her work was included in Lippard's travelling exhibition *Soft and Apparently Soft Sculpture* in 1968, at that time she used materials that one would more readily associate with a sculptural practice, such as marble, plaster, wax, bronze or latex. Man Ray's wool-covered sewing machine *L'Enigme d' Isodore Ducasse* 1920 (fig.71) and Meret Oppenheim's 'fur teacup' *Object* 1936 are both cited frequently as examples of Surrealist sculptures that employ textiles or soft materials in order to make everyday objects strange or uncanny. In the mid-1960s Claes Oldenburg made the medium of soft sculpture his own, creating absurd everyday objects on a huge scale in soft, fabric form. Though he was associated with Pop art, his objects may have influenced another female Surrealist, Dorothea Tanning, who was born a year before Bourgeois and who started to make soft sculptures in the mid-1960s. Tanning's *Hôtel du Pavot, Chambre 202* (Poppy Hotel, Room 202) 1970–3 is a significant installation in which the walls and floor of a mock hotel room are populated by strange stuffed figures, sometimes morphing into the walls and furniture.

In the late 1960s and early 1970s, at the time when Oldenburg and Tanning were producing fabric works within a sculptural tradition, many women artists began to use textiles to develop feminist practices that celebrated, questioned or resisted the traditional associations of the feminine with domesticity and home crafts. Most notable are Judy Chicago and Miriam Shapiro, who collaborated together with a group of students to create the exhibition *Womanhouse* in a derelict house in Hollywood in 1972, and who are both well known for their celebratory appropriation of craft practices such as embroidery or quilting. Roszika

Dorothea Tanning
NUE COUCHÉE 1969–70 [72]
Mixed media 38.5 x 108.9 x 53.5
Tate

Parker and Griselda Pollock's important book *Old Mistresses: Women, Art and Ideology*, first published in 1981, addresses the way in which women's work has been sidelined in the history of art. In one passage they state:

This division of so-called 'fine art' extends to the distinction between art and craft. Women's practice in the forms of art using needle and thread have been dismissed as painstaking and merely dexterous, while great art is defined as intellectually testing and truly inventive, qualities that are only exercised by men. These differences have been misrepresented to us as a hierarchical division between great art and lesser decorative crafts.[76]

In parallel with the feminist developments, an increasing number of artists in the 1960s became associated with what was known as 'fiber arts' in the United States, exploring the language and techniques of textiles and insisting that it presented a valid artistic medium.

In 1969 Bourgeois wrote a review of the exhibition *Wall Hangings* at the Museum of Modern Art, New York, which was first published in *Craft Horizons* magazine that year. In her review Bourgeois explains that for her, tapestry could be three-dimensional and not just a wall-hanging: 'In the beginning tapestries were indispensable, they were actually movable walls, or partitions in the great halls of castles . . . They were a flexible architecture . . . I, myself, have very long associations with tapestries. As children, we used them to hide in. This is one reason I expect them to be so three-dimensional.'[77]

She goes on to explain that in her opinion the exhibition did not push the textile medium far enough, since an opportunity to explore fabric in three dimensions was not really pursued. In the following statement, she pre-empts some of the techniques she herself would take up in later years:

I could think, for instance, of all kinds of turned shapes – cubes or any three-dimensional forms that could have been used. The pieces in the show rarely liberate themselves from decoration and only begin to explore the possibilities of textiles. They can be woven in shape and then made rigid by spraying. They can be stretched over armatures, draped and pulled.[78]

Bourgeois's assertion that the textiles on display 'rarely liberate themselves from decoration' is in keeping with her commitment to the practice of sculpture. It is a telling statement, revealing her assumptions about decorative art – or what may be considered as 'craft' – and its inadequacy as 'fine art'. A product of her training and development as a young artist in France and the intellectual and social circle of the New York art world, Bourgeois believed that art must represent and make tangible certain ideas and emotions. The stuffed-fabric pieces that Bourgeois began to make in the 1990s could be described as soft sculpture, having more in common with the biomorphic stuffed works of Dorothea Tanning such as *Nue couchée* 1969–70 (fig.72), or the contemporary practice of French artist Annette Messager, than with the fiber art and feminist developments of the 1960s and 1970s. Bourgeois worked on many of these stuffed sculptures in the house. Whilst they emerge from the domestic realm, and indeed reflect upon the family relationships that proved to be Bourgeois's lifelong obsession, these works do not necessarily make an explicit feminist statement; nor do they mark any clear departure from her earlier themes.

In an article titled 'Forum: Women in Art', published in *Arts Magazine* in 1971, Bourgeois responds to the question, 'How do you feel about the position of women in the art world today?' with the following statement: 'A woman has no place as an artist until she proves over and over that she won't be

SEVEN IN BED 2001 [73]
Fabric and stainless steel
29.2 X 53.3 X 53.3

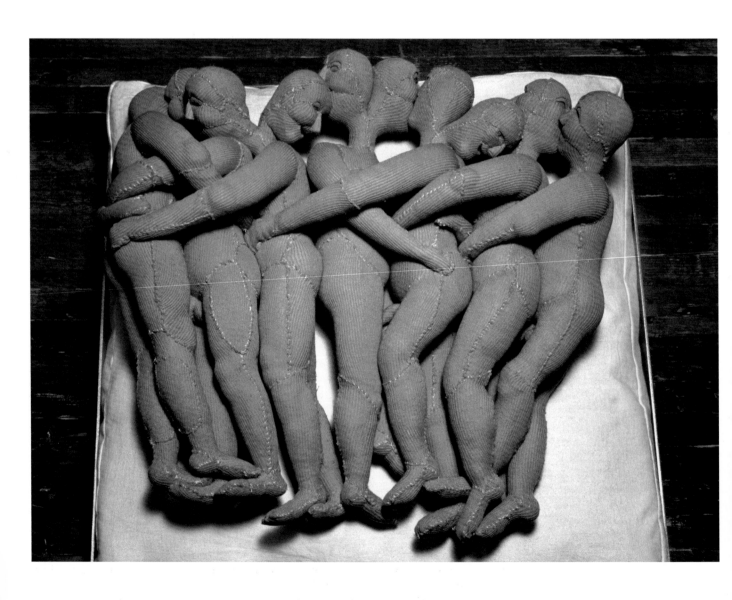

COUPLE 2001 [74]
Fabric, hanging piece 50.8 x 17.7 x 15.2
Collection Ursula Hauser,
Switzerland

eliminated.'[79] Perhaps Bourgeois's desire to be taken seriously as an artist is one of the reasons why she did not use sewing as a medium for making sculpture until late in life, when she may have felt less pressure to prove herself. In a somewhat controversial article of 1974, 'Soft Art et Les Femmes' (Soft Art and Women), art-historian Aline Dallier argued that women are drawn towards soft art by their common experience. As she concludes, 'Despite the fact that some men also work in soft art, it is, above all, and more than a style or an artistic movement, a link between women of all conditions.'[80] Perhaps Bourgeois wished to avoid the possibility that she was doing 'women's work'. As Lippard pointed out, 'It took a man, Claes Oldenburg, to make fabric sculpture acceptable, though his wife, Patty, did the actual sewing.'[81] In another interview of 1971, Bourgeois is asked, 'Do most men consider you an artist, a woman artist, or a woman?', to which she replies, 'They consider me a woman first, and an artist second (but not a "woman artist").'[82] In the androgynous state of old age, when her concern with being a wife, a lover, etc., had run its course, Bourgeois had become free to make stitched and stuffed sculpture from the clothing (and equivalent 'roles') that she had cast off. She was able to take the logical next step in her oeuvre, without the possible conclusion that she was in the business of creating 'women's art' or that her art should in some way be confined or reduced to the domestic realm in which she physically existed, and that she had in fact long explored as her subject.

Bourgeois's stuffed fabric sculptures fall into three categories: figures and body parts; heads; and stacked towers. The figures – individuals, couples, mothers with child, and sometimes whole groups – are like gruesome, grown-up stuffed toys, crudely stitched and fashioned from the kinds of fabrics one might find packed away in a chest or closet: pink, blue or orange terry-cloth towelling, heavy flannels, blue-and-white striped cotton ticking, felt and old nylon stockings. As anyone with experience of dressmaking will know, the skill of creating three-dimensional sculptural shapes from fabric lies in the cutting. Bourgeois's figures are often made from a patchwork of cut and assembled pieces that form the shape of feet, knees, elbows, breasts, nipples, eyelids, etc. Sometimes the finished pieces are suspended, as in Arch of Hysteria 2000, or Couple 2001 (fig.74). Others are caged within small cells or vitrines.

A row of seven stuffed pink adult figures are packed together like sardines in Seven in Bed 2001 (fig.73). Some of the figures have two heads and are facing both ways, adding to the sense that the scene is some kind of incestuous orgy. The bed is encased in a vitrine, the small-scale figures presented like specimens to be examined by the viewer. The horizontal, linen-covered surface of the bed recalls Bourgeois's earlier references to the parents' bed in Red Room (Parents) 1994, and the family dinner table in The Destruction of the Father: 'Two things count in one's erotic life: dinner table and bed. The table where your parents made you suffer. And the bed where you lie with your husband, where your children were born and you will die. Essentially, since they are about the same size, they are the same object.'[83]

The dramas of family life are represented again, on an even smaller scale, in two works that group together a number of intricately made, doll- or puppet-like figures. The Reticent Child 2003 (fig.75) is a theatrical maquette originally created for the Freud Museum in Vienna. The soft figures are set out on a contrasting clinical, stainless-steel and aluminium table, backed by a concave mirror. Bourgeois was clearly dissecting, analysing and reflecting upon her relationship with her son Alain, whose life is

THE RETICENT CHILD 2003 [75]
Fabric, marble, stainless steel and
aluminium 182.8 x 284.4 x 91.4

REJECTION 2001 [76]
Fabric, steel and lead
63.5 x 33 x 30.5
Collection John Cheim

represented by the figures, from the artist's pregnancy and his birth through to adulthood. A similar work titled *Oedipus* also shows the various stages of life, though this time in a seemingly less personal and more universal capacity. Bourgeois's stuffed figures appear to represent the states of vulnerability encountered in human life.

In Bourgeois's emotionally charged, fleshy pink soft sculptures, the gaps in the stitching and roughly patched-up areas are a reminder of the porous quality of our own skin and the delicacy of the flesh that may succumb to sickness or trauma. A further series of fabric heads appears to present us with portraits of universal emotional states, rather than individual human likenesses. *Rejection* 2001 (fig.76) has an expression of anguish, with its mouth fixed open to let out a cry for help. The heads are presented in simple standing vitrines and are rendered in a variety of fabrics including tapestry, striped ticking and cotton towelling. One of the heads, *Untitled* 2002, is made from a predominantly red-and-blue tapestry fabric. The pieces are carefully cut and placed so that the eyes are created from the blues in the fabric and the mouth is lined in red. Made up of fragments of tapestry woven from yarn dyed the most common and predominant colours used in the restoration business (cochineal and indigo), this stuffed bust could be a portrait of the artist's past. But the fabric works also express universal states of human suffering. Bourgeois exhibited alongside the Viennese Baroque sculptor Franz Xaver Messerschmidt, whose character heads exploring facial expressions were also shown with works by Francis Bacon – an artist whom Bourgeois greatly admired – in the exhibition *Francis Bacon, Louise Bourgeois, Franz Xaver Messerschmidt: A Juxtaposition of the Three Artists* at Cheim & Read, New York, in 1998. Messerschmidt and Bacon both depicted the human face and body, reflecting states of emotional and psychological trauma or breakdown. Bacon's painterly renditions of flayed flesh and Messerschmidt's modelled heads are transformed by Bourgeois into soft sculptures.

In contrast to these highly charged figurative pieces, Bourgeois also produced a series of fabric towers, employing textiles in the production of geometric, repetitious columns made up of cushion-like elements (fig.77). Pushing the fabric to its limits, these towers seem to defy gravity. They adopt the activities of stacking, building and repeating that had been a constant source of stability for Bourgeois in an unstable and threatening world. The abstraction and verticality of the fabric towers make them rare in Bourgeois's recent vocabulary of soft sculptural forms, though there are obvious similarities with the stacked wooden pieces of the 1950s.

In 2007 Bourgeois made a new series of works, titled *Echo*. Old clothes were draped, stretched and sewn into position. The flaccid shapes were then cast in bronze and painted white, giving them a ghostly appearance, especially when they were displayed against blood-red painted walls in the Hauser & Wirth Colnaghi gallery in London (fig.78). The *Echo* pieces are also reminiscent of certain of the *Personages* from the 1950s, having the same scale and presence in the room, though now they are softer, fatter and heavier, weighed down by gravity and the burden of time. Perhaps these are the ghosts of the personages, echoes from the past that the artist wishes finally to cast off, but which she has difficulty letting go. Perhaps they are a way of confronting the experience of being trapped in an ageing body and a domestic existence where the world is closing down and things need to be sorted through, cast off or recycled. The sculptures, like Bourgeois's pieces from the 1960s, have the

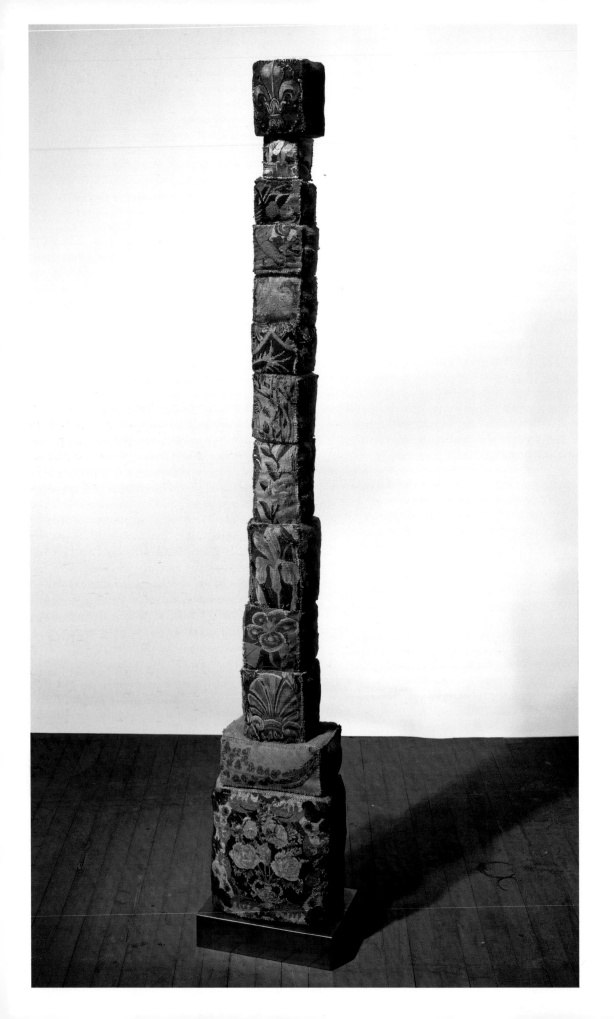

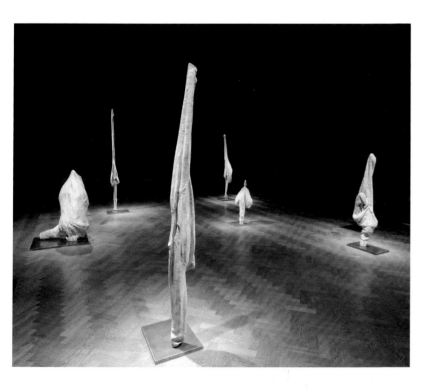

appearance of softness, yet they are cast in a medium that is made to last. In the following poem, Bourgeois perfectly expressed the complex emotions and associations that were aroused through sorting her old clothing:

> *Very very difficult*
> *To get rid of all the clothes*
> *I do not use this year*
>
> *What do they represent:*
> *failures,*
> *rejects,*
> *abandoned*
>
> *Left because of Guilt,*
> *ties me to them*
> *(increasing,*
> *unlived,*
> *unwanted,*
> *ineffectual)*
>
> *To remember the failures*
> *Is a right to complain*
>
> *Pretext not to move ahead*
>
> *Laziness,*
> *to like it.*[84]

Whilst she may have been clearing out her closets, the artist was also making sure that the materials from her home would outlive her in their new incarnation as sculpture. Certainly, there is nothing emotionally soft or nostalgic about Bourgeois's late works. These sculptures reveal a boldness and emotional intensity that come with age.

Bourgeois made several limited-edition books throughout her career. *Ode à l'oubli* 2002 (figs.79, 80) is an exquisite book made of cloth. On each page different fabrics are appliquéd, quilted, layered or embroidered. The materials are selected from the stash of linens that the artist collected over her lifetime, including the set of monogrammed napkins from her bridal trousseau that serve as the backing for many of the pages. The mostly red, blue or pink fabric pieces are carefully cut, assembled and stitched together to create a series of colourful, geometric, abstract relief 'drawings' that tell a story perhaps only truly readable to the artist herself.

The title translates approximately as 'Ode to Forgetfulness', though Bourgeois seems to be referring to a kind of Proustian involuntary memory that may surface as the pages are turned and the cloths bring up their associations for her. Among the abstract patterns and shapes there are two statements printed in red ink onto the fragile linen: 'I had a flashback of something that never existed' and 'The return of the repressed'. Her interest is clearly in the memories that are buried deep in the unconscious: 'To reminisce and woolgather is negative. You have to differentiate between memories. Are you going to them or are they coming to you? If you are going to them, you are wasting time. If they come to you, they are the seeds for sculpture.'[85]

Ode à l'oubli is the logical development of earlier experimental works such as *Untitled (I Have Been to Hell and Back)* 1996, where Bourgeois embroidered a stained blue and white cotton handkerchief with this statement, using the lines on the cloth as her notepaper. The pages of *Ode à l'oubli* also resemble a set of Bourgeois's drawings, such as *The Insomnia Drawings* 1994–5. The characteristic lines, shapes and colours are there: stacked towers; egg-like shapes contained within a circle; ever-decreasing rectangles; knotty, snake-like threads; woven and patch-worked squares. In Bourgeois's practice the act of drawing becomes confused with that of stitching, weaving or knitting, whether she uses pen or fabric. Translating her drawings into stitched works, Bourgeois reverses the processes undertaken by Sonia Delaunay, who sourced ideas for her richly coloured, geometric drawings, paintings and designs from an interest in Russian peasants' quilt-making, and Delaunay's own experiment in making a coverlet for her son. Bourgeois also had a love of geometry. Her pleasure in the repetition of diagonal lines and neat grids is certainly apparent in this book. The thirty-six pages of *Ode à l'oubli* are each buttoned at the binding, so that they can be easily taken out of their covers for display. Sometimes they are shown in a grid formation on the wall, emphasising the inventiveness of each page and again resembling a handcrafted patchwork quilt or wall-hanging.

ODE À L'OUBLI 2004 [79]
Fabric and colour lithograph book,
36 pages, 27.3 x 33.6 x 5

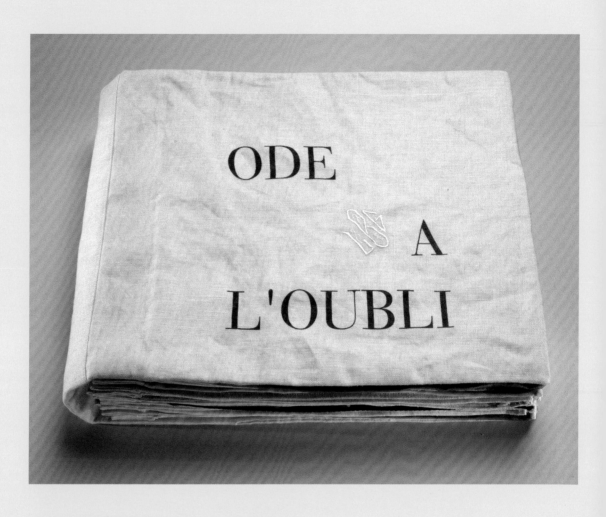

Bourgeois worked with a seamstress to finish the book, which has also been painstakingly reproduced as an edition of twenty-five with seven artist's proofs. She made a similar book, *Ode à la Bièvre*, also in 2002. Unlike many of Bourgeois's stitched and stuffed sculptures with their heavy-handed sewing and frayed edges, these books are meticulously crafted, yet they still incorporate the stains and marks of time that show up on the used fabrics (and are replicated in the editions). The tears in a blue cloth are embroidered with red thread that draws attention to their oval shape, suggestive of eyes or eyelets. Sewing is a way of drawing things together, of repairing or even 'embroidering' the past in glorious colour and detail. Yet Bourgeois was keen not to stitch up all the gaps, stains and holes:

> *What disconcerts me are the holes in my memory, those of continuities.*
> *The coming back from the war and the Spanish influenza. Jerk . . .*
> *There are holes in my memory, its continuity doesn't pay off, it's moth-eaten.*
> *Retrace your steps.*
> *My memory is moth-eaten, full of holes.*[86]

I had a flashback
of something
that never existed

The
return
of
the
repressed

ODE À L'OUBLI 2004 installed at the
Butler Gallery in Kilkenny, Ireland 2006 [80]

Le désir : vous me /rrez cent lignes – non 200 lignes

3/19/77

6

I have three kinds of diaries: the written, the spoken (into a tape recorder), and my drawing diary, which is the most important. Having these various diaries means that I keep my house in order. They must be up-to-date so that I'm sure life does not pass me by.[87]

Bourgeois had been in the habit of keeping a diary since the age of twelve. The daily activity of recording her thoughts and feelings in journals and notebooks was for her a kind of 'tender compulsion'. Like a musician practising scales, or a dancer limbering up, the daily practice of writing and drawing kept the artist's creative energy flowing, enabling her to draw upon the thoughts, feelings and memories that were often lurking deep in the well of her subconscious mind.

Bourgeois's passion for writing was inspired by its combined ability to conjure up associations and connections in the mind's eye and to purge certain thoughts and emotions: 'I love language . . . You can stand anything if you write it down . . . words put in connection can open up new relations . . . a new view of things.' She wrote numerous poems, statements and notes throughout the years. Early in her career, Bourgeois produced a print portfolio titled *He Disappeared into Complete Silence*, combining a poetic text with a sequence of engravings. In later years, words started to be incorporated into her sculptures, in particular the *Cells*, where statements are welded in metal, or painted and embroidered onto cloth. These statements often make plain the artist's beliefs about the significance of creating and the struggle to escape her demons: 'Art is a Guaranty of Sanity'; 'Pain is the ransom of formalism'; 'The cold of anxiety is very real'.

In the private realm of her diaries, she wrote in both French and English, whilst the majority of statements and interviews were conducted in English. The handwriting that populates her notebooks and drawings has a fast and frantic quality. Single lines are sometimes repeated over and over again on the page, like a schoolchild's punishment of writing lines. The page is crammed with words written in an elegantly old-fashioned, but increasingly unsteady hand. Some of her drawings are simple written statements, or what are referred to as 'writing-drawings'. The words are perhaps the most basic and often repeated statements in all human relationships, revealing the speaker's child-like vulnerability and needs: 'Do you love me, yes or no?' or *Je t'aime* repeated again and again in red ink (fig.81). In her later years, and with the assistance of those who surrounded her, Bourgeois recorded in audio form her statements, discussions, songs, poems and even rap songs. The spoken word can conjure different associations to that written on the page and the artist had a habit of singing nursery rhymes or songs that she remembered from her early years in France. Returning to her notebooks, she also made lists. Bourgeois had a fascination with dictionaries and encyclopedias, perhaps for the sense of certainty, security and completeness they provide. Her own lists appear to be obsessive attempts to make an extended autobiographical record so that 'no detail of this life may be forgotten'. She even made a list of lists, which begins:

1. The list of friends

2. The list of neighbours

3. The list of addresses

4. The list of schools

5. The list of students

and ends:

37. The list of imponderables

38. The list of catalysts

39. The list of injuries and blasphemies

40. The list of day and night-time activities

41. The list of works to be done, letters to answer today

42. The list of subjects you haven't mentioned [88]

THE SWEET SMELL OF INDIGO 1968 [82]
Watercolour, charcoal and gouache
on paper 48.9 x 63.5
The Metropolitan Museum of Art,
New York

Yet words alone were not enough for Bourgeois. The visual and physical activities of drawing and making sculpture were more powerful for her than the written word, providing greater protection in her battle against the 'cold of anxiety'. She produced drawings with the same regularity as her written diaries, suggesting that drawing was more than just a way to plan ideas for her sculptures (for the most part Bourgeois's drawings do not correlate to her sculptures). As she said: 'Drawings are thought feathers, they are ideas that I seize in mid flight and put down on paper. All my thoughts are visual. But the subjects of my drawings are not translated into sculpture until several years later. As a result, there are lots of things that appear in drawings that are never explored further.'[89]

Since the Renaissance, drawing has mostly been viewed as a secondary medium, used for the process of planning a painting or sculpture, or for observing life and nature. In the twentieth century the Surrealists and the Abstract Expressionists found new uses for drawing as an 'automatic' link to the unconscious or as an expressive, gestural tool. For Minimalism and Conceptual art, drawing became an important, primary medium, often employed to communicate an idea, or to work through a series of propositions or a given formula. Though all of these twentieth-century forms of drawing appear in different ways in Bourgeois's works on paper, her drawings also had a therapeutic motivation.

Bourgeois drew on whatever she has to hand – the back of an envelope, graph paper, musical score sheets – using ink, charcoal, pencil, crayon, etc. The resulting images are sometimes figurative, sometimes abstract, or with elements of both figuration and abstraction. Themes present themselves as thoughts or statements that recur or resurface over the years, sometimes with obvious connection to her sculptural practice and sometimes not. Bourgeois's imagery is drawn from the imagination, the internal landscape of the mind, and she makes no attempt at realist representation. Her subjects include families, child-like figures, houses, architectural and mechanical structures, water, plants and natural forms, geometric scenarios and conundrums, knots and skeins, and anything else that can be used to pin down her thoughts, feelings and memories. Marie-Laure Bernadac believes that 'The drawings provide the artist with direct access to the past – to memory and to the unconscious. In that respect they are a form of writing.' The drawings, like the diaries, are records. Both activities can be used to create order from chaos or to purge negative states, and therefore to restore a sense of calm and a vital sense of security. As Curator Lawrence Rinder points out: 'Although she takes great pleasure in their creation, for Bourgeois, making drawings is as necessary as locking the door at night.'[90]

If one were to compile a lengthy list of Bourgeois's drawings, it might begin with those she was tasked to produce as a young girl when her talents were put to use for the restoration of tapestries, or following that, the precise drawings she would have made as a student of solid geometry at the Sorbonne. Schooled at the École des Beaux-Arts during her later turn to the arts, she would have received instruction in life-drawing and other classical techniques and methods. Her experience in the studios of Fernand Léger and André Lhote becomes evident in early paintings with their neo-Cubist, compartmentalised compositions, strong colours and heavy lines. Bourgeois's early drawings, however, are often more clearly figurative and more difficult to date, their look similar to those she produced later in life. Ink sketches on graph paper may take the form of self-portraits (fig.83), or show whimsical, cartoon-like figures including the *Femme Maison*. Family relationships are also explored. There

are clear links between her more private drawings and
the wooden sculptures that she publicly displayed in
her exhibitions at the Peridot gallery. Speaking about
her early drawings, Bourgeois said: 'At one point I
stopped making self-portraits, and I included the
people that lived with me. I would say that it had to do
with the problem of the *toi* and the *moi*, of the you and
the me.'[91]

In 1946, Bourgeois started regularly to attend
Atelier 17, the engraving studio of Stanley William
Hayter, an English artist who had left Paris for New
York at the start of the Second World War. Print-
making was an activity that Bourgeois could work on
and prepare at home, and she also enjoyed the
company of other artists at the atelier. It was here that
she produced her book *He Disappeared into Complete
Silence* 1947. Nine monochrome intaglio prints are
placed alongside a text written by the artist. The
images depict a strange kind of architecture: precarious
standing towers, hybrid structures and a claustro-
phobic room full of ladders leading to nowhere. The
text appears to bear no direct relation to the images,
but instead sets out a number of pathetic scenarios of
human disappointment and despair. In the same year
Bourgeois wrote a story titled *The Puritan*, based on
Alfred H. Barr Jr., then Director of the Museum of
Modern Art, New York. The story was first published
in 1990 in a limited edition with eight engravings of
abstract, geometric structures, including a kind of
ladder made up of horizontal planes (fig.84). These
prints remind us of the artist's love of geometry and
the careful and precise form of mathematical drawing
with repeated shapes and lines that contrasts so much
with her rough, cartoon-like drawings.

A series of drawings that Bourgeois made in the
1940s and 1950 was inspired by the rocky mountainous
region of Creuse in central France. Repetitive black ink

THE PURITAN: FOLIO SET NO.3, detail [84]
Suite of eight hand-coloured
engravings and text in linen-covered
portfolio, each 66 x 101.6
Courtesy of Osiris

lines grow organically across the page, like plants. They look similar to the flowing hair of the early painted women on the rooftops, or like the drawings of skeins of wool. *Throbbing Pulse* 1944 (fig.85) seems to represent mountains or waves. In the mid-1960s, Bourgeois made a further series of drawings of repetitive, organic forms, though this time they are dominated by the rounded, semi-circular scalloped shapes that are also prevalent in the sculpture of the same period, for example in *Cumul i* 1969, *Avenza* 1968–9, or later in *Partial Recall* 1979. Bourgeois stated that the process of creating the more abstract drawings was for her a form of meditation:

if you meditate, you become aware of your breathing and of your pulse. And when you are aware of both – of your breathing and the pulse – then you can really settle down and eventually fall asleep. Which is the idea. I'm an insomniac, so for me the state of being asleep is a paradise I can never reach. But I still try to conquer the insomnia, and to a large extent I have done it; it is conquerable. My drawings are a kind of rocking or stroking and an attempt at finding a kind of peace. Peaceful rhythm. Like rocking a baby to sleep.[92]

The Insomnia Drawings, a suite of 220 drawings produced between November 1994 and May 1995, were made mostly when Bourgeois was unable to sleep. These works on paper were predominantly executed in red ink, often on lined paper, or musical-score paper. Figurative and abstract images are interspersed throughout. Among other things, the drawings show landscapes, buildings, plants, waves, birds and people as well as semi-abstract repetitive marks that seem to mimic needlework and clearly functioned for the insomniac artist as a way of passing time. Water is one of the most prevalent themes in the figurative drawings. On the back of one related drawing Bourgeois wrote:

During the night I am afraid to be alone
So I call my friends to keep me company
And they all come up out of the water.[93]

And elsewhere: 'Sleep is running on stagnating water.'[94]

A widely recognised symbol of the unconscious, water held a particular significance for Bourgeois in relation to her childhood memories of living by the rivers that were so necessary to the process of dyeing wool for tapestries. The *Insomnia Drawings* and accompanying notes make references to floods, dams, lock and sluice gates. In one drawing, a girl, rendered in red ballpoint pen on lined paper, is drowning in the foreground of the picture (fig.89). Rain is coming down, and behind her a row of trees lines a driveway leading to her house. On the back of the sheet of paper Bourgeois had written 'la noyée dans la Bièv' (the person who drowned in the Bièvre River). This person we assume to be the young Louise, whom the older artist wishes to send to her watery grave. Other images show plants growing up from a water-logged ground, or rain making waves and ripples in the water's surface. In a later drawing from the series, a person kneels on the ground, attempting to pull up a plant that we can see has a deeply established network of roots below. On the reverse of this drawing are the following lines: 'The digging out of forgotten events. Unconscious memories you dig out or else they keep bothering you.'

The *Insomnia Drawings* seem to have provided a dual function: the abstract, rhythmic ones were an attempt to meditate and to bring on sleep, while the figurative drawings and written notes record the thoughts and memories that would drift across the artist's semi-conscious mind, bothering her with their presence and preventing the sleep for which she longed. Often, these images represent the deep-seated

THROBBING PULSE 1944 [85]
Ink on paper 48.8 x 32.3
The Museum of Modern Art,
New York

CUMULS 1972 (recto) [86]
Watercolour on paper 66 x 101

THE INSOMNIA DRAWINGS
1994–5, detail [87]
220 mixed media works on paper,
various dimensions
Daros Collection, Switzerland

Louise Bourgeois drawing at the
living room table of her Chelsea
home, 2000 [88]

THE INSOMNIA DRAWINGS
1994–5, detail [89]
220 mixed media works on paper,
various dimensions
Daros Collection, Switzerland

fears of the unconscious. As Bourgeois explained: 'The abstract drawings come from a deep need to achieve peace, rest and sleep. They relate to unconscious memories ... [In contrast, the realist drawings represent the] overcoming of negative memory, the need to erase and to get rid of it.'[95]

The abstract drawings, then, operate at the surface, having a pacifying, stroking, soothing effect upon the artist, while the figurative drawings dig deep into the depths in order to weed out the memories that may have been disturbing her. This duality of surface and depth, reason and chaos, calm and turbulence is echoed in both the subject matter and the way in which the drawings are rendered. Whilst many of the figurative drawings appear to have been created in a hurry and by a trembling, unsteady hand, the abstract ones are often neater and more certain. Bourgeois said that she often needed the aid of a compass to draw circles, and the tool lends several of her geometric drawings a more precise and calculated quality. Typical of Bourgeois's work, the duality present and implicit in these drawings reveals the two sides of the same coin: without the struggle, there is no need to ease the tension; and without the ability to calm herself, the artist would be unable to plunge the depths.

Tous les Cinque II 2004 (fig.90) is a suite of seventy-six mixed-media drawings, each one showing five hand-drawn concentric circles, mostly in red but with small touches of blue appearing here and there. The circles are mesmerising, especially when viewed en masse. They bring to mind the ripples of water when a stone is thrown in, or the round and oval metal-framed mirrors that recur in many of Bourgeois's works. Other themes that reappear in her later works on paper, as well as her sculptures, are scissors and cutting implements, references to sewing and weaving, and spiders. For Bourgeois, these things

often refer to her mother. One drawing from 1986 shows a small pair of scissors dangling below a larger pair. 'It's me and my mother', she explained. Three sheets of brown paper recording columns of three- and four-digit numbers are stitched together in *Untitled* 1993. Though it is not clear what these numbers record, Bourgeois said that 'this represents the handwriting of my mother, who was terribly, terribly careful'.[96] Perhaps it was from her mother that Bourgeois learned the importance of keeping her 'house in order', at least metaphorically.

In her later years, Bourgeois once again took up printmaking. She had a small press in her house, and a number of trusted individuals assisted in translating her drawings into editioned prints. Drawing, writing and printmaking were accessible to the aged artist, just as they were when she was a young woman at home with her children. Her working space had once again become the large table in her back parlour where she sat and drew, using margarine tubs and old jars as palettes and containers for brushes and pens (fig.88). It seems that the practice of this most productive and extraordinary artist had come full circle.

TOUS LES CINQUE II 2004 [90]
Suite of seventy-six mixed media
drawings with cover page,
each 24.1 x 21.3

Plate 1

Once there was a girl and she loved a man.

They had a date next to the eighth street station of the sixth avenue subway.

She had put on her good clothes and a new hat. Somehow he could not come. So the purpose of this picture is to show how beautiful she was. I really mean that she was beautiful.

Plate I Louise Bourgeois

Plate 2

The solitary death of the Wool-
worth building.

Plate 2 Louise Bourgeois

Plate 3

Once a man was telling a story,
it was a very good story too, and
it made him very happy, but he
told it so fast that nobody under-
stood it.

Plate 3 Louise Bourgeois

Plate 4

In the mountains of Central France forty years ago, sugar was a rare product.

Children got one piece of it at Christmas time.

A little girl that I knew when she was my mother used to be very fond and very jealous of it.

She made a hole in the ground and hid her sugar in, and she always forgot that the earth is damp.

Plate 4 Louise Bourgeois

Plate 5

Once a man was waving to his friend from the elevator.

He was laughing so much that he stuck his head out and the ceiling cut it off.

Plate 5 Louise Bourgeois

Plate 6

Leprosarium, Louisiana.

Plate 6 Louise Bourgeois

Plate 7

Once a man was angry at his wife, he cut her in small pieces, made a stew of her.

Then he telephoned to his friends and asked them for a cocktail-and-stew party.

Then all came and had a good time.

Plate 7 Louise Bourgeois

Plate 8

Once an American man who had been in the army for three years became sick in one ear.

His middle ear became almost hard.

Through the bone of the skull back of the said ear a passage was bored.

From then on he heard the voice of his friend twice, first in a high pitch and then in a low pitch.

Later on the middle ear grew completely hard and he became cut off from part of the world.

Plate 8 Louise Bourgeois

Plate 9

Once there was the mother of a son. She loved him with a complete devotion.

And she protected him because she knew how sad and wicked this world is.

He was of a quiet nature and rather intelligent but he was not interested in being loved or protected because he was interested in something else.

Consequently at an early age he slammed the door and never came back.

Later on she died but he did not know it.

Plate 9 Louise Bourgeois

HE DISAPPEARED INTO COMPLETE
SILENCE 1947 [91 a–i]
Suite of nine engravings with text,
each 25.4 x 35.5

Umbilical Cord 2003 – one of Bourgeois's handmade, stuffed-fabric sculptures – takes the form of a pregnant woman with large, pillow-like breasts, no arms and a surprisingly delicate transparent mesh bump through which one can see her tiny, stitched baby. For the duration of Bourgeois's exhibition at the Museum of Capodimonte in Naples, 2007–8, the figure could be seen standing on a plinth, placed in dialogue with early Renaissance painter Pietro Perugino's *Holy Virgin with Child* 1496–8 (fig.92). One of a number of Bourgeois's works positioned as temporary interventions into the halls of the museum, the small pink pregnant figure appeared to be contemplating the Madonna and Child seated above her. This particular dialogue between Old Master painting and contemporary sculpture seemed to beg the question: is this a painting with which a pregnant woman may feel an affinity, or is it an intimidating reminder of certain religious and cultural values associated with motherhood and maternity, values that loom large over the woman who is soon to give birth?

Whilst 'mother and child' images can be found in abundance in the history of western art, there are surprisingly few true attempts to represent pregnancy – the pregnant body and especially the pregnant subject. *Making Visible Embryos*, an online exhibition created by the University of Cambridge, explores the 'visual history of the unborn from medieval art and medicine through to ultrasound scans and test tube babies'.[97] One of the most striking images included in the exhibition is an eighteenth-century oil painting taken from a sandstone sculpture of the expectant Virgin Mary made between 1400 and 1410 (fig.93). The baby Jesus is seen inside a rectangular opening or transparent section of the Virgin's torso. Though such images of 'The Virgin of the Expectation' were prevalent in the late middle ages, they were deemed indecent by the Catholic Church during the reformation. Subsequent depictions of Mary typically stress her virginity, heavily symbolised in paintings of the annunciation, and her maternity, as demonstrated in the many paintings of Madonna and Child, with little to signify the time of gestation in between. The pregnant body, as conceptualised through the cult of the Virgin, is a mysterious, sealed vessel that becomes meaningful only when it produces a child. While advances in medicine have expanded our ability to open up and look inside the envelope of the womb, they have largely focused on the unborn fetus and have also added little to our understanding of pregnancy from the expectant mother's point of view.

In her essay 'Motherhood According to Giovanni Bellini', first printed in 1975, cultural theorist Julia Kristeva considers religious and artistic representations of maternity. She makes a clear statement about the inadequacy of the dominant discourses to describe or understand the state of being pregnant:

This becoming-a-mother, this gestation, can possibly be accounted for by means of only two discourses. There is science; but as an objective discourse, science is not concerned with the subject, the mother as site of her proceedings. There is Christian Theology (especially canonical theology); but theology defines maternity only as an impossible elsewhere, a sacred beyond, a vessel of divinity, a spiritual tie with the ineffable godhead, and transcendence's ultimate support – necessarily virginal and committed to assumption.[98]

Though Kristeva argues for an alternative discourse of maternity, she acknowledges that in pregnancy there is no coherent, unified subject position from which to speak: 'no one is present within that simultaneously dual and alien space to signify what is going on. It happens, but I'm not there.'[99] In a further essay, 'Stabat

Mater' – first published in 1977 shortly after the birth of her son – Kristeva combines her theoretical text with a poetical reflection on her own experiences of pregnancy and birth. Like a written equivalent of Bourgeois's visual intervention at the Museum of Capodimonte, Kristeva's text dares to put her own creative, maternal voice in dialogue with a consideration of the cult of the Virgin Mary, fraying the edges of a previously seamless narrative.

Much has been written about motherhood in relation to Bourgeois – both the artist and her work – and it is arguably her most important and abiding concern. As Marie-Laure Bernadac has stated:

The artist does not omit any stage of maternity, from pregnancy through fecundity, giving birth, the role of the mother (good or bad) ... Few artists have so frequently and explicitly dealt with the birth-scene, the swelling of the womb, breast-feeding, the umbilical cord, the anguish of being unable to have children, and the painful responsibility that children represent.[100]

Themes such as fertility, gestation, reproduction, metamorphosis, the pregnant body, the maternal encounter, and the psychology of the pregnant woman were present in Bourgeois's practice for decades. Despite this, there have been no focused attempts to consider her representations and reflections on the specific state of pregnancy. When Lucy Lippard declared that Bourgeois's works from the 1960s implied 'the location of metamorphosis rather than the act', she could have been alluding to the space that Kristeva later described as 'dual and alien' – in literal terms, the pregnant womb. Bourgeois's literal and metaphoric explorations of the pregnant mind / body have taken many different forms, but it is possible to focus on some of her most repeated images and ideas, drawing out her particular ability to make transparent what has been left out of the picture in the dominant discourses on maternity.

Gravity

In 1939 Bourgeois became pregnant for the first time; she had previously believed herself to be infertile and had already adopted her eldest son Michel. It was during this first pregnancy that she developed a fear of falling. The medical term for a woman in her first pregnancy – primagravida – is derived from the word 'gravid' or heavy, referring to the gravitational weight and burden of carrying a child. Bourgeois's fear of falling is likely to have originally been related to her fear of failing in her responsibilities as a mother, or of miscarrying her pregnancy. As she later explained: 'A woman who carries packages is responsible for what she carries and they are very fragile, and she is totally responsible. Yes, it is a fear of not being a good mother.'[101]

Whilst almost all of Bourgeois's *Personages* from the late 1940s and early 1950s address issues of fragility, balance and verticality, *Woman with Packages* 1949 and *Pregnant Woman I* 1947–9 (fig.94) appear to make an explicit connection with the fear of gravity that the artist experienced during her pregnancy (and perhaps later as a mother of three children). The *Pregnant Woman* first appears in a photograph of sculptures in progress in Bourgeois's studio, circa 1945, propped in front of a radiator with its low-slung belly wrapped in fabric. While it was unusual for Bourgeois to introduce fabric at this point in her career, she created a similar form in the *Echo* series made many years later in 2007, where bronze casts are taken from old sweaters and other garments. The artist saw the softness, folds and femininity of these bronzes as relating to maternal feelings of nurturing, protection and warmth. Bourgeois's anthropomorphic sculptures also appear to capture the feeling of weight and gravity bearing down and distorting the body, or even the depressed psyche with which the body is so

Installation view of Louise Bourgeois's UMBILICAL CORD 2003 (fabric and stainless steel) in dialogue with Pietro Perugino's HOLY VIRGIN WITH CHILD, Museo di Capodimonte, Naples 2008 [92]

THE PREGNANT VIRGIN [93]
Oil on canvas 22.6 x 15.1
Diocesan Museum, St Pölten, Austria

closely linked. The *Pregnant Woman* that she created in the 1940s reflected the physical and psychological weight of responsibility she was carrying in her childbearing years. Bourgeois spoke of her maternal anxiety, explaining that it

persisted after conception. This is not something which disappears. For instance, when the children are much older you are afraid of something else. You are afraid of losing them; you are afraid of being abandoned; you are afraid of becoming aggressive; you are afraid of lots of things. So it is not a thing which stops once they are born. It diminishes, but it does not stop.[102]

Returning to Kristeva's poetic text in 'Stabat Mater', gravity and the abyss are used as metaphors to explain the gap that opens up between the mother and child after birth, and the gulf of non-meaning, the 'division of language' that accompanies the 'division of the flesh', creating a further fear for the new or expectant mother of losing herself, her own identity, as well as the fear of losing her child (feelings commonly experienced by women suffering from post-natal depression): 'Then there is this other abyss that opens up between the body and what has been inside: there is the abyss between the mother and the child. Trying to think through that abyss: staggering vertigo. No identity holds up.'[103]

Kristeva writes about her maternal experiences in spatial metaphors, using the fear of falling from a height, or vertigo, as an analogy. Interestingly, Bourgeois also referred to her work as an artist using a similar spatial metaphor in an often-quoted statement: 'My early work is the fear of falling. Later on it became the art of falling.' Bourgeois would have doubtless followed Albert Camus's Existentialist interpretation of gravity and the inevitable outlined in his essay *The Myth of Sisyphus* (1942). The figure of Greek mythology is forever condemned to push a rock up a mountain, only to see it roll back down each time he reaches the top. According to Camus, Sisyphus's surrender to gravity, his acceptance of the absurd, leads to his liberation. For Bourgeois, art – the creative act – is both a struggle against gravity and an acceptance or expression of it. It may also be a means to escape the weight of depression, a 'guarantee of sanity': 'We have tunnel missions and we have bottom-of-the well vision. If you visualize yourself down there, the question is, how are you going to get out? This philosophy is an optimistic philosophy. By hook or by crook, you are going to get yourself out. And I always did. But how? By drawing.'[104]

Speaking about her representations of the pregnant woman, Bourgeois could almost be referring to the situation of being an artist, and the defensiveness she may have felt at that later time about her 'child' the artwork:

I try to give a representation of a woman who is pregnant and who tries to be frightening . . . She tries to be frightening but she is frightened for the child she carries. And she's afraid somebody is going to invade her privacy or bother her in some way and she won't be able to defend what she's responsible for.[105]

And about her drawing *Girl Falling* 1947, she said:

Even though this is a very happy and beautiful feeling, we do hope that it is not too much for her . . . we hope that she is not going to be crushed by the weight of the responsibility. We hope that she is up to it . . . that she doesn't fall. The axis over her head means that her balance is precarious. She better be careful . . . The fear of losing balance forces you to be conscious of physical structure. You become very good at that if you become a sculptor . . . you have to.[106]

Bourgeois also spoke of a woman's menstrual period as being her 'best, most creative time', again linking female fertility with artistic creation and generation.

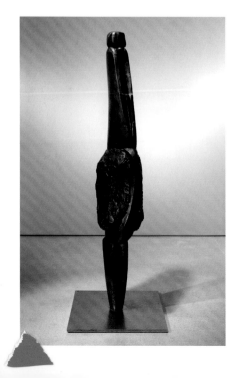

PREGNANT WOMAN I 1947–9 [94]
Bronze 121.9 x 40.6 x 40.6

An artist who attempted to make a very direct visual and verbal record of her own experience of pregnancy is Susan Hiller, whose project *10 Months* 1977–9 (fig.95) charts the growth of her pregnancy through a series of photographs of her 'bump' accompanied by text from her journal setting out her thoughts and feelings. Hiller realised that the average pregnancy is not really nine calendar months in length, but ten lunar months or cycles which, like the tides, may possibly be connected to the pull of the moon's gravity. Her images link the fertile body to the landscape (albeit a lunar landscape) in a similar manner to many of Bourgeois's sculptures from the 1960s. In both of these cases, the artist may have looked beyond the Christian traditions of maternity to more archaic sources as fertile ground for alternative ways of understanding and representing the pregnant subject.

Goddess

Multi-breasted women appear in many of Bourgeois's works. In an untitled drawing from 1948, Bourgeois simply depicts a woman whom she later identified as 'the good mother', apparently weighed down by her many full breasts. The woman in *Girl Falling* 1947 (fig.96) also appears to be burdened by breast-like shapes, though this time the title and the placement of the appendages inside the woman's belly indicate that she is pregnant. Both images show women who have been taken over by their reproductive function, multiplying beyond regular human capacity. The multi-breasted figures are also reminiscent of the latex moulds with which Bourgeois had experimented in the 1960s and 1970s as costumes for the performers of *A Banquet / A Fashion Show of Body Parts* and for her own photographic portrait. *Self-Portrait* 2007 (fig.97), a set of red gouaches, shows another woman with five breast shapes hanging from her neck like an enormously cumbersome necklace. The title suggests that Bourgeois – the 'multigravida', mother in a family of five persons – still saw herself as a generator of life. Her ability to create and generate was both a blessing and a burden. Art historians and critics such as Barbara Rose, Anne M. Wagner, Thomas McEvilley and Lucy Lippard have compared Bourgeois's earlier fertile figures to ancient Greek or Paleolithic goddesses. As McEvilley points out, the Greek goddess Artemis, also known as Polymastos or many-breasted, is represented in statues with a number of rounded elements on her torso. These are usually understood to be breasts, though they could also represent the castrated bulls' testicles that were put around the neck of the statues as a way of symbolising sacrifice. The ambiguity that arises from these two alternative interpretations of the Artemis figures seems fitting as a comparison for Bourgeois's similarly nurturing, but threatening (in Freudian terms, castrating) mothers.

For Lippard, the various roughly formed, pregnant female torsos and figures that Bourgeois created in the 1960s (and recreated in later years in fabric or marble) were reminiscent of the Venus of Willendorf, a Paleolithic, carved female fertility figure with exaggerated breasts, belly and behind. Bourgeois's figures, rendered in plaster and clay or cast in bronze, are often without a head or limbs. Sometimes the woman has an extended neck, pointing upwards in a phallic manner above her high, rounded breasts. Giving her figures such titles as *Harmless Woman* 1969, or *Fragile Goddess* 1970 (fig.98), Bourgeois indicated that she saw them as being vulnerable, though with their jutting breasts and phallic appearance, they are certainly not weak or defenceless. The lack of arms or legs often seems in fact to intensify the strength

Susan Hiller
TEN MONTHS 1977–9, detail [95]
Ten photographs and ten captions;
installed size 203 x 518
Moderna Museet, Skeppsholman,
Stockholm

GIRL FALLING 1947 [96]
Ink and charcoal on paper
28.5 x 18
Private collection, California

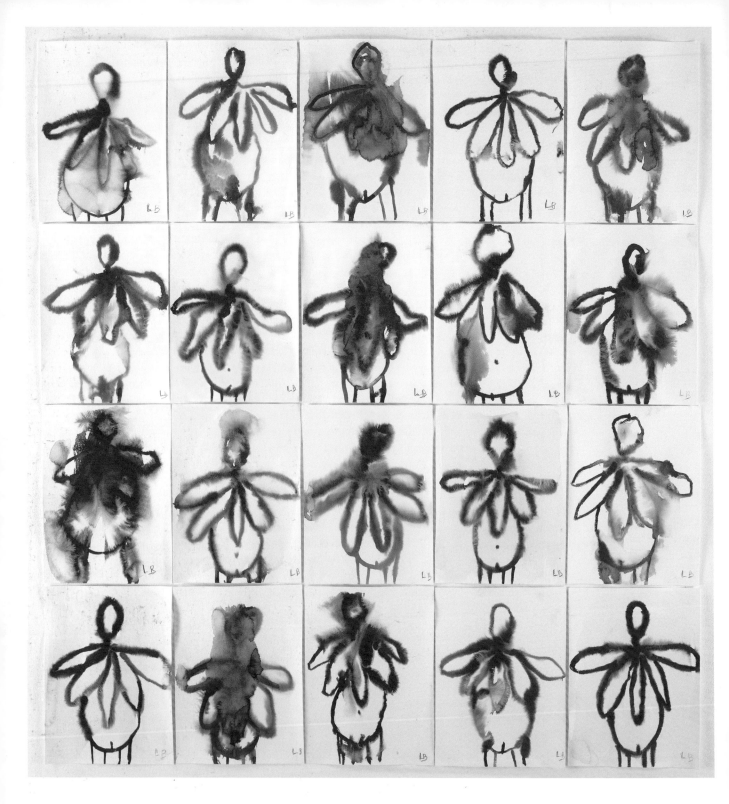

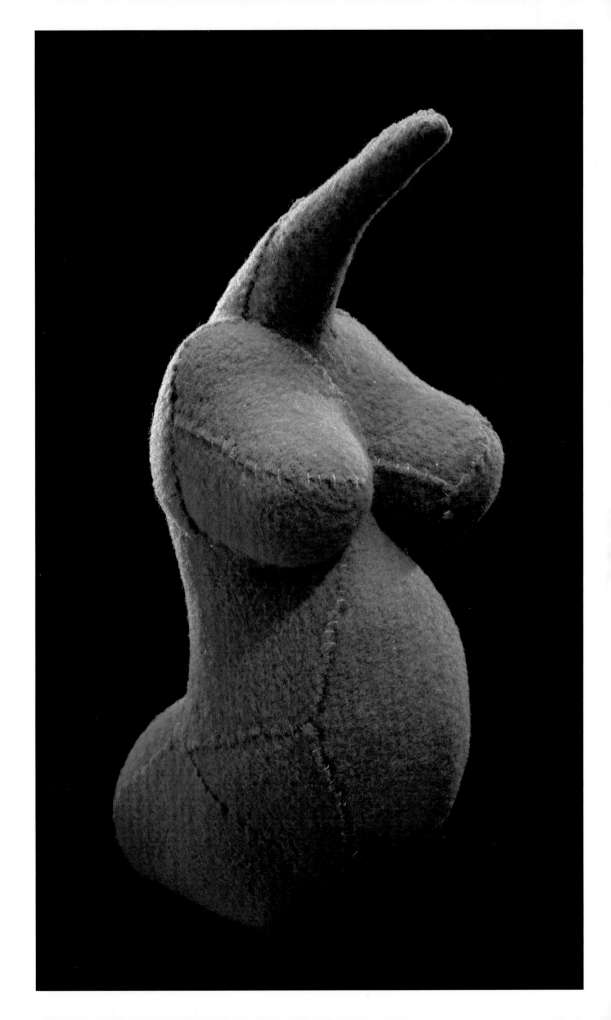

SELF-PORTRAIT 2007 [97]
Suite of twenty, gouache
on paper, each 36.8 x 27.9

FRAGILE GODDESS 2002 [98]
Fabric 31.8 x 12.7 x 15.2

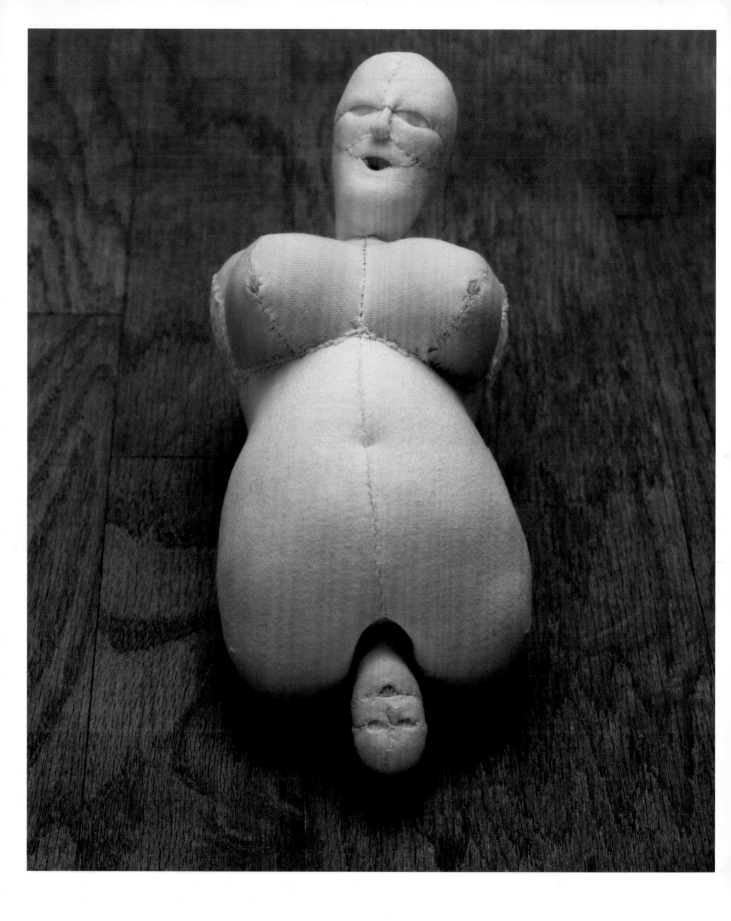

of the remaining, essential body parts, and in developing her female figures into works such as *Femme Couteau*, Bourgeois actually turns the woman's body into an aggressive blade. On other occasions Bourgeois presented a pregnant woman with a wooden leg, inspired by her sister Henriette, and again highlighting the woman's combined power and vulnerability:

For instance, when you talk about this last piece of the pregnant wooden-leg-lady, there is no wit in it at all. I'm not trying to be funny – it is fact. It is a pathetic vision – I'm not sure it is pathetic, it is a very positive and friendly vision of my sister, who always inspired a great deal of compassion in me, and who desperately wanted children and never had any, and who hobbled around with a cane and a stiff knee due to water-on-the-knee . . . I'm just trying to say that you can be pregnant even though you have a stiff knee.[107]

A more recent comparison for Bourgeois's limbless goddess figures may be found in Mark Quinn's 2005 commission for the fourth plinth at Trafalgar Square, a marble statue of the disabled artist Alison Lapper, showing her pregnant body naked. Quinn's portrait was celebrated as a symbol of strength and resilience (though Lapper has since spoken widely about her struggle to receive critical recognition as an artist for her own representations of her body). In works such as *The Arrival* 2007 (fig.99) Bourgeois's limbless women are giving birth, the lack of legs and arms serving to highlight the double-headed, Janus-like moment of their divided existence. In a drawing of a birthing mother dating from 1941 (fig.100), Bourgeois has enlarged the child's head so that it is as big as that of the mother, as if she is giving birth to a kind of homunculus or fully grown child. Compared with the clearly celebratory representations of pregnancy and birth produced by artists such as Monica Sjöö (*God Giving Birth* 1968; fig.101), or Niki de Saint Phalle (*Hon* 1966), Bourgeois's images indicate an ambivalence or a double-headed position that Mignon Nixon has described as 'the fantastic reality of the maternal role . . . embracing the mother and the death drive at once'.[108] For Bourgeois, once a woman becomes a mother she is always a divided subject.

Matrix

In the 1990s, Bourgeois extended the theme of the defensive mother into her series of sculptural spiders. In nature, the female spider guards her eggs by weaving a sac that is often larger than her own body. *Maman* carries eggs in her sac, while another large steel spider crouches protectively over a mesh cell containing tapestry fragments. Though Bourgeois had declared that she associated the spider with her own mother, the weaver and restorer, her spiders have a wider appeal, drawing on myth and legend and symbolising female strength and motherhood. In a later series of stitched works including *The Reticent Child* 2003 (referring to her last-born child Alain) and *The Woven Child* 2002 (frontispiece), the artist presents a tiny human baby in a net or woven sac like the gestational sac. Continuing the theme of weaving and maternal protection, Bourgeois's delicate pink figures again seem to speak of both her specific experiences of motherhood and more universal aspects of our coming-into-being as subjects in the world.

It is easy to find examples of womb-like environments in Bourgeois's work, from the *Lairs* of the 1960s, to the *Cells* and *Red Rooms* of the 1990s. She appears to have had a compulsion to build houses, nests or environments that may cocoon and comfort, but simultaneously threaten to trap us. The word

THE ARRIVAL 2007, detail [99]
Fabric, glass, wood and
stainless steel
142.2 x 60.9 x 50.8

UNTITLED (WOMAN GIVING
BIRTH) 1941 [100]
Ink on graph paper 27.9 x 21.6
Kunstmuseum Basel

Monica Sjöö
GOD GIVING BIRTH 1968 [101]
Oil on hardboard 183 x 122
Museum Anna Nordlander,
Skelleftea, Sweden

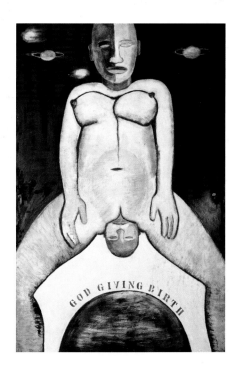

'matrix', meaning womb, origin and web (and linking female biology with the systems used in textiles and mathematics), is taken up by the artist and theorist Bracha L. Ettinger, who presents a theory of prenatal and pre-maternal psychic experience that she terms the 'matrixial' encounter between the mother and child. Unlike Kristeva, who declared that 'no-one is present' in that encounter, Ettinger attempts to explain the development of human subjectivity as co-emerging at this time from a shared psychic space. As adults, we may experience fleeting or uncanny memories of this 'archaic' state of connectivity with the mother that has remained almost invisible or unrepresented in our lives, surfacing in the form of art. According to Kristeva, a woman is able once again to enter into contact with her own mother when she herself gives birth: 'Such an excursion to the limits of primal regression can be phantasmatically experienced as a reunion of a woman-mother with the body of her mother.' This theory is echoed in a statement that Bourgeois made in 1981: 'If you hold a naked child against your naked breast, it is not the end of softness, it is the beginning of softness, it is life itself . . . I felt that when I represented the two naked bodies of the child and the mother, I can still feel her body and her love.'[109]

Art historian Griselda Pollock has argued that Bourgeois's maternal loss – the artist's traumatic experience of losing her own mother at a relatively young age – has found particular expression in her sculpture *Maman*, the title being like the voice of a young child calling out to her mother in fear and longing (*Maman!*). In 1932, following the death of her mother, Bourgeois sought stability and certainty in the study of geometry and mathematics at the Sorbonne. When she realised that no such stability

was to be found, she turned to the creative possibilities of art and was eventually able to address the maternal loss that haunted her and drove her to create a body of work that brought her closer to the body of *her* mother. As she said: 'Fear of abandonment has stayed with me my whole life. It began when my father left for the war. It continued when my mother died in 1932. People ask me to "be their mother". I can't because I'm looking for a mother myself.'[110]

In a BBC television programme made in 2007 at the time of her retrospective exhibition at Tate Modern, Bourgeois is filmed in her home in New York while working on her new series of red gouache drawings. Looking at the striking images of birthing mothers and small children at the breast, her interviewer asks if she identifies with the mother or the child. After a long pause, Bourgeois replies, 'The child'. Putting aside the clichéd understanding of old age as a form of second childhood, Bourgeois's response provides a clue as to why, at the age of ninety-six, she started to produce a shockingly bold body of drawings examining fertility, pregnancy and childbirth, and also how we might understand these images looking beyond the artist's personal motivations. Bourgeois's blood-red, embryonic drawings address the moments in life when one is either merged with the mother or violently separated. Her work accesses this primal state of being or becoming, the trauma of arriving into the world and its continuing impact upon our lives. In one image, *The Birth* 2007 (fig.102), a child is emerging, arms first, from the mother's body, as if consciously diving out into the unknown abyss that exists below the edge of the page. This was Bourgeois's great project: generating life and struggling with its complexities through an art that shielded her, like the maternal body, from the next great unknown.

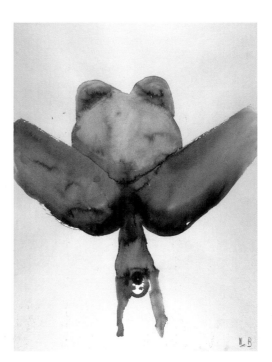

THE BIRTH 2007, detail [102]
Gouache on paper 60 x 45.7

SELF-PORTRAIT 2009 [103]
Drypoint, archival dyes, ink and embroidery on cloth 314.3 x 231.7

Notes

1 Mignon Nixon, 'Bad Enough Mother', *October*, no.71, Winter 1995, pp.71–92.

2 Louise Bourgeois, *Louise Bourgeois: Album*, New York 1994. Reprinted in Marie-Laure Bernadac and Hans Ulrich Obrist (eds.), *Louise Bourgeois: Destruction of the Father, Reconstruction of the Father: Writings and Interviews 1923–1997*, Cambridge, Mass. and London 1998.

3 Louise Bourgeois, 'An Artist's Words', first published in *Design Quarterly, The Walker Art Center, Minneapolis*, no.30, p.18. Reprinted in Bernadac and Obrist 1998.

4 Robert Storr, 'Abstraction: L'Esprit géométrique', in Frances Morris (ed.), *Louise Bourgeois*, exh. cat., Tate Modern, London 2007.

5 Louise Bourgeois, 2003, unpublished manuscript, quoted in Thomas Kellein, *Louise Bourgeois: La Famille*, exh. cat., Kunsthalle Bielefeld, Bielefeld 2006, p.16.

6 Nemecio Antúnez, exhibition announcement for *Louise Bourgeois: Paintings*, Norlyst Gallery, New York 1947.

7 Louise Bourgeois, letter to Colette Richarme, 7 March 1938, in Bernadac and Obrist 1998, p.26.

8 Jennifer Dalsimer, 'Lousie Bourgeois's Sexual Imagery and her Relationship to the Feminist Movement', unpublished thesis, 1986, Louise Bourgeois Archive.

9 Bourgeois, letter to Richarnme, 19 January 1940, in Bernadac and Obrist 1998, p.37.

10 Interview with Paulo Herkenhoff, 11 April 1997.

11 Bourgeois, letter to Richarme, 31 August 1939, in Bernadac and Obrist 1998, p.36.

12 Louise Bourgeois, 'Natural History', 1944, first published in *Personal Statement: Painting Prophecy 1950*, exh. cat., David Porter Gallery, 1945. Reprinted in Bernadac and Obrist 1998, p.44.

13 Ibid.

14 Jerry Gorovoy and Danielle Tilkin, 'There's No Place Like Home', in *Louise Bourgeois: Memory and Architecture*, exh. cat., Museo Nacional Centro de Arte Reina Sofía, Madrid 1999, p.15.

15 Ibid.

16 Louise Bourgeois, *The Puritan* (1947), first published by Osiris Editions, New York 1990. Reprinted in Bernadac and Obrist 1998, p.51.

17 Bernadac and Obrist 1998, p.45.

18 Louise Bourgeois, diary, 28 March 1986.

19 Louise Bourgeois, diary, 13 March 1994.

20 Quoted in Marie-Laure Bernadac, *Louise Bourgeois: Recent Work*, exh. cat., capc Musée d'art Contemporain de Bordeaux / Serpentine Gallery, London 1998, p.40.

21 Louise Bourgeois quoted in Christine Meyer-Thoss, *Louise Bourgeois: Designing for Free Fall*, Zurich 1992, p.177.

23 Stuart Morgan, 'Taking Cover: Louise Bourgeois Interviewed by Stuart Morgan', *Artscribe International*, January–February 1988, pp.30–4.

23 Robert Storr, 'Meanings, Materials and Milieu: Reflections on Recent Work by Louise Bourgeois. From an Interview with Robert Storr', *Parkett*, no.9, 1986, pp.82–5.

24 Marsha Pels, 'Louise Bourgeois: A Search for Gravity', *Art International*, vol.23, no.7, October 1979, pp.46–54.

25 Susi Bloch, 'An Interview with Louise Bourgeois', *Art Journal*, vol.35, no.4, Summer 1976, pp.370–3.

26 Louise Bourgeois, 18 March 2000, Louise Bourgeois Archives.

27 Robert Storr, 'Louise Bourgeois', *Galleries Magazine*, international edition, June–July 1990. Reprinted in Jerry Gorovoy and Pandora Tabatabai Asbahi, *Louise Bourgeois: Pink Days and Blue Days*, exh. cat., Fondazione Prada, Milan 1997.

28 Louise Bourgeois, undated quote, Louise Bourgeois Archives.

29 Robert Storr, *Arachne on 20th Street: Louise Bourgeois. Homesickness*, exh. cat., Jokohaman taidemuseo 1997, p.138.

30 Robert Goldwater, *What Is Modern Sculpture?*, The Museum of Modern Art, New York 1969.

31 William C. Seitz, *The Art of Assemblage*, exh. cat., The Museum of Modern Art, New York 1961.

32 Storr 1986.

33 Select statements by Louise Bourgeois, first published in Christiane Meyer-Thoss, *Louise Bourgeois: Designing for Free Fall*, Zurich 1992, pp.177–202, reprinted in Bernadac and Obrist 1998, p.230.

34 Lucy R. Lippard, 'Louise Bourgeois: From the Inside Out', *Artforum*, vol.13, no.7, March 1975, pp.26–33.

35 David Robbins, 'Sculpture by Louise Bourgeois', *Art International*, vol.8, October 1964.

36 Lucy R. Lippard, 'Eccentric Abstraction', in Morris 2007, pp.112–13.

37 Lucy R. Lippard, 'Eccentric Abstraction', *Art International* (Lugano), vol.10, no.9, November 1966, pp.34–40.

38 Lynn F. Miller and Sally S. Swenson, *Lives and Works: Talks with Women Artists*, New Jersey 1981, pp.5–6.

39 Marie-Laure Bernadac, *Sculpting Emotion*, Paris 2006, p.100.

40 Georges Bataille, *Visions of Excess: Selected Writings, 1927–1939*, ed. and trans. Allan Stoekl, Minneapolis 1985, p.31.

41 Lippard 1975.

42 Bernadac and Obrist 1998, p.74.

43 Ibid., p.91.

44 Ibid., p.81.

45 Ibid., p.76.

46 Ibid., p.91.

47 Ibid., p.101.

48 Bernadac and Obrist 1998, p.183.

49 Rosalind Krauss, 'Fillette 1968', in Morris 2007, p.146.

50 Meyer-Thoss 1992, p.69.

51 Select statements by Louise Bourgeois first published Meyer-Thoss 1992, pp.177–202, reprinted in Bernadac and Obrist 1998, p.225.

52 *Bad Girls*, New Museum, New York (curated by Marcia Tucker), 1994, and Wight Art Gallery, Los Angeles (curated by Marcia Tanner), 1994.

53 Bernadac and Obrist 1998, p.205. 'On Cells', first published in *Carnegie International*, exh. cat., Carnegie Museum of Art, Pittsburgh 1991.

54 Judith Russi Kirschner, 'Louise Bourgeois: "Femme Maison". The Renaissance Society at the University of Chicago', *Artforum*, vol.20, November 1981, p.88.

55 Gorovoy and Asbaghi 1997, p.142.

56 Louise Bourgeois, quoted in Meyer-Thoss 1992, p.53.

57 Deborah Wye, *Louise Bourgeois*, exh. cat., The Museum of Modern Art, New York, 1982.

58 Ibid.

59 Louise Bourgeois, quoted in Paul Gardner, 'The Discreet Charm of Louise Bourgeois', *Art News*, no.79, February 1980, p.27.

60 Louise Bourgeois, quoted in Paul Gardner, *Louise Bourgeois*, New York 1994.

61 Meyer-Thoss 1992, p.47.

62 Storr 1986, pp.82–5.

63 Meyer-Thoss 1992, p.137.

64 Suzanne Pagé and Béatrice Patent, *Louise Bourgeois: Sculptures, environments, dessins 1938–1995*, exh. cat., Musée d'art moderne de la Ville de Paris, Paris 1995.

65 Pat Steir, 'Mortal Elements', *Artforum*, Summer 1993, quoted in Gorovoy and Asbaghi 1997, p.206.

66 Interview with Marie-Laure Bernadac, *Pensée-plumes*, exh. cat., Musée national d'art moderne, Centre Georges Pompidou, Paris 1995. Reprinted in Bernadac and Obrist 1998, p.298.

67 Louise Bourgeois, 28 February 2000, quoted in Morris 2007, p.32.

68 Louise Bourgeois, taped interview with Cecilia Blomberg, October 1968.

69 Louise Bourgeois, quoted in Morris 2007, p.50.

70 Primo Levi, *Other People's Trades*, London 1989.

71 Louise Bourgeois, extract from 'Ode to My Mother', 1995.

72 Paulo Herkenhoff notes, 16 November 1995, in Morris 2007.

73 Interview with Paulo Herkenhoff, 'Louise Bourgeois: Femme-Temps', in Gorovoy and Asbaghi 1997, p.268.

74 Meyer-Thoss 1992, p.178.

75 Paulo Herkenhoff in Morris 2007, p.187.

76 Rozika Parker and Griselda Pollock, *Old Mistresses: Women, Art and Ideology*, London 1981.

77 Louise Bourgeois, 'The Fabric of Construction', *Craft Horizons*, vol.29, no.2, pp.30–5. Reprinted

in Bernadac and Obrist 1998, p.89.

78 Ibid.

79 Cindy Nemser, 'Forum: Women in Art', *Arts Magazine*, 1971. Reprinted in Bernadac and Obrist 1998, p.97.

80 Alline Dallier, 'Le Soft Art et les femmes', *Opus International*, September 1974, no.52, pp.49–54, trans. Coline Millard.

81 Lucy R. Lippard, *The Pink Glass Swan: Selected Feminist Essays on Art*, New York 1995, p.135.

82 Bernadac and Obrist 1998, p.95.

83 Eleanor Munro, *Originals: American Women Artists*, New York 1979, pp.154–9. Reprinted in Bernadac and Obrist 1998, p.115.

84 Louise Bourgeois, *Echo*, New York 2008.

85 Louise Bourgeois, 'Self-Expression Is Sacred and Fatal' (1992), in Bernadac and Obrist 1998.

86 Louise Bourgeois, diary entry, 1994.

87 Louise Bourgeois, 'Tender Compulsions', *World Art*, February 1995, no.2, p.108.

88 Paulo Herkenhoff, 'Louise Bourgeois: Femme-Temps', in Gorovoy and Asbaghi 1997, pp.264–5.

89 Louise Bourgeois, quoted in Bernadac 1995.

90 Louise Bourgeois and Lawrence Rinder, *Louise Bourgeois: Drawings & Observations*, published to accompany an exhibition at University Art Museum and Pacific Film Archive, University of California, Berkeley 1995, p.12.

91 Ibid., p.53.

92 Ibid., p.107.

93 Louise Bourgeois, *The Insomnia Drawings*, ed. Marie-Laure Bernadac, Zurich 2001.

94 Ibid .

95 Paulo Herkenhoff and Angelica de Moraes, *Louise Bourgeois: desenhos / drawings*, exh. cat., Centro Cultural Light, Rio de Janiero 1997, p.29.

96 Bourgeois and Rinder 1995, p.174.

97 http://www.hps.cam.ac.uk/visibleembryos/

98 Julia Kristeva, 'Motherhood According to Giovanni Bellini', in *Desire in Language: A Semiotic Approach to Literature and Art*, Leon Roudiez (ed.), Columbia University Press, New York 1980, pp.237–8.

99 Ibid.

100 Marie-Laure Bernadac in Morris 2007, p.175.

101 Alain Kirili, 'The Passion for Sculpture: A Conversation with Louise Bourgeois', *Arts Magazine*, March 1989, p.71.

102 Louise Bourgeois in conversation with Deborah Wye, in Bernadac and Obrist 1998, p.47.

103 Julia Kristeva, 'Stabat Mater', trans. Leon S. Roudiez, in Toril Moi (ed.), *The Kristeva Reader*, Blackwell, Oxford 1995, p.173.

104 Louise Bourgeois in Bourgeois and Rinder 1995, p.76.

105 Louise Bourgeois, interview in Miller and Swenson 1981, quoted in Wye 1982.

106 Louise Bourgeois, quoted in Deborah Wye and Carol Smith, *The Prints of Louise Bourgeois*, The Museum of Modern Art, New York 1994, p.225.

107 Louise Bourgeois, 14 October 1981, Louise Bourgeois Archives.

108 Mignon Nixon, *Fantastic Reality: Louise Bourgeois and a Story of Modern Art*, Cambridge, Mass. 2005, p.12.

109 Louise Bourgeois in Bernadac and Obrist 1998, pp.127–8.

110 Louise Bourgeois, quoted in Susan L. Stoops, *The Woven Child*, exh. cat., Worcester Art Museum, Worcester, Mass. 2006, p.26.

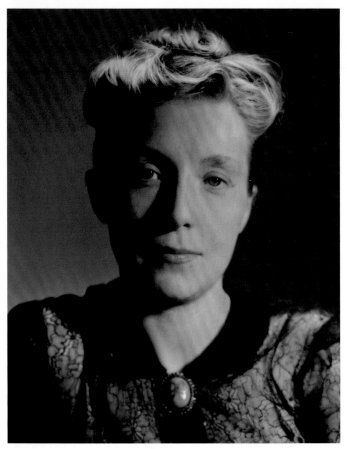

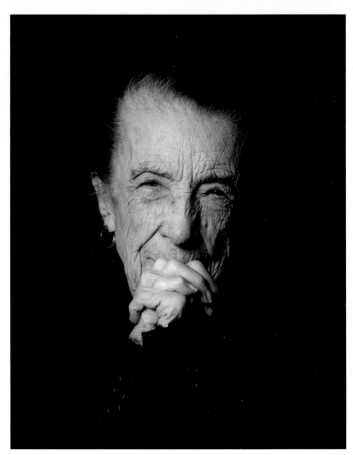

Louise Bourgeois, 1949
Photo: Berenice Abbott

Louise Bourgeois, 2000
Photo: Michèle Mattei

Biography

1911	Born in Paris, France
1938	Moves to New York City
1955	4 October: becomes an American citizen
2010	Dies in New York City

Education:

1921–7	Lycée Fénelon and Collège Sévigné
1932–5	Sorbonne, Paris
1936–7	École du Louvre
1936–8	École des Beaux-Arts
1937–8	Academie de la Grande Chaumiere

Selected Solo Exhibitions

1945 *Paintings by Louise Bourgeois*, Bertha Schaefer Gallery, New York

1949 *Louise Bourgeois, Recent Work 1947–1949: Seventeen Standing Figures in Wood*, Peridot Gallery, New York

1950 *Louise Bourgeois: Sculptures*, Peridot Gallery, New York, NY

1953 *Louise Bourgeois: Drawings for Sculpture and Sculpture*, Peridot Gallery, New York

1964 *Louise Bourgeois: Recent Sculpture*, Stable Gallery, New York

1974 *Louise Bourgeois: Sculpture 1970–1974*, 112 Greene St Gallery, New York

1978 *Louise Bourgeois: New Work*, Hamilton Gallery of Contemporary Art, New York; includes the performance *A Banquet / A Fashion Show of Body Parts* in conjunction with the piece *Confrontation* (21 October).

1979 *Louise Bourgeois, Sculpture 1941–1953: Plus One New Piece*, Xavier Fourcade Gallery, New York

1980 *The Iconography of Louise Bourgeois*, Max Hutchinson Gallery, New York

1982–4 *Louise Bourgeois: Retrospective*, Museum of Modern Art, New York: touring to Contemporary Arts Museum, Houston; Museum of Contemporary Art, Chicago Akron Art Museum, Akron, Ohio

1989–91 *Louise Bourgeois: A Retrospective Exhibition*, Frankfurter Kunstverein, Frankfurt: touring to Stadtische Galerie im Lenbachhaus, Munich; Musée d'art Contemporain, Lyon; Fundación Tàpies, Barcelona; Kunstmuseum, Bern; and Kröller-Müller Museum, Otterlo

1993–6 American Pavilion, Venice Biennale: an expanded exhibition, *Louise Bourgeois: The Locus of Memory*, touring to the Brooklyn Museum of Art, Brooklyn, New York; The Corcoran Gallery of Art, Washington, D.C.; Galerie Rudolfinum, Prague; Musée d'Art Moderne de la Ville de Paris, Paris; Deichtorhallen, Hamburg; Musée d'Art Contemporain de Montréal, Montreal

1995–6 *Louise Bourgeois*, MARCO, Monterrey, Mexico; touring to Centro Andaluz de Arte Contemporaneo, Seville; Museo Rufino Tamayo, Mexico City

1999–2000 *Louise Bourgeois: Architecture and Memory*, Museo Nacional Centro de Arte / Reina Sofia, Madrid

2001–2 *Louise Bourgeois*, Guggenheim Museum Bilbao, Bilbao

2001–3 *Louise Bourgeois at the Hermitage*, The State Hermitage Museum, St Petersburg: touring to Helsinki City Art Museum, Helsinki; Kulturhuset, Stockholm; Museet for Samtidskunst, Oslo; Louisiana Museum of Modern Art, Humlebæk

2002 *Louise Bourgeois: Works in Marble*, Galerie Hauser & Wirth, Zurich

2003–5 *Louise Bourgeois*, Irish Museum of Modern Art, Dublin: touring to the Fruitmarket Gallery, Edinburgh; Centre of Contemporary Art Málaga, Malaga; Museum of Contemporary Art, North Miami

2003– *Louise Bourgeois Installation at Inauguration of Dia:Beacon*, Dia Center for the Arts, Beacon, New York (long-term loan)

2007–8 *Louise Bourgeois: Retrospective*, Tate Modern, London: touring to the Centre Georges Pompidou, Paris; Solomon R. Guggenheim Museum, New York; Museum of Contemporary Art, Los Angeles; Hirshhorn Museum & Sculpture Garden, Washington D.C.

2008 *Louise Bourgeois: Nature Study*, Inverleith House, Royal Botanical Gardens, Edinburgh

Louise Bourgeois: Echo, Cheim & Read, New York

2008–9 *Louise Bourgeois for Capodimonte*, Museo Nazionale di Capodimonte, Naples

2009 *Louise Bourgeois: A Stretch of Time*, Galerie Karsten Greve, Cologne

2010 *Louise Bourgeois: Les Fleurs*, Kukje Gallery, Seoul, Korea

Louise Bourgeois, The Museum of Cycladic Art, Athens

Louise Bourgeois: The Fabric Works, Fondazione Vedova, Venice: touring to Hauser & Wirth, London

2010–11 *Bellmer / Bourgeois: Double Sexus*, Sammlung Scharf-Gerstenberg, Nationalgalerie, Berlin: touring to Gemeentemuseum, The Hague

Louise Bourgeois: Eugénie Grandet, Maison de Balzac, Paris

2011 *Louise Bourgeois: The Return of the Repressed*, Fundación Proa, Buenos Aires: touring to Instituto Tomie Ohtake, São Paulo; Museu de Arte Moderno, Rio de Janeiro

2011–12 *Louise Bourgeois: À L'Infini*, Foundation Beyeler, Riehen / Basel

Selected Books and Articles

1976 Lucy R. Lippard, 'Louise Bourgeois: From the Inside Out', in Lippard, *From the Center: Feminist Essays on Women's Art*, New York; previously published in *Artforum*, vol.13, March 1975, pp.26–33

1982 Deborah Wye, *Louise Bourgeois*, exh. cat., The Museum of Modern Art, New York

1986 Robert Storr, 'Meanings, Materials and Milieu: Reflections of Recent Work by Louise Bourgeois, from an Interview with Robert Storr', *Parkett*, no.9, pp.82–5

1989 Peter Weiermair with Lucy Lippard et al., *Louise Bourgeois*, exh. cat., Frankfurter Kunstverein, Frankfurt. English version published Zurich 1995

1992 Christiane Meyer-Thoss, *Louise Bourgeois: Designing for Free Fall*, Zurich

1994 Charlotta Kotik, Terrie Sultan, Christian Leigh, *Louise Bourgeois: The Locus of Memory. Works 1982–1993*, exh. cat., Brooklyn Museum, New York
Deborah Wye and Carol Smith, *The Prints of Louise Bourgeois*, exh. cat. / catalogue raisonné, The Museum of Modern Art, New York

1995 Louise Bourgeois and Lawrence Rinder, *Louise Bourgeois: Drawings & Observations, published to accompany an exhibition at University Art Museum and Pacific Film Archive*, University of California, Berkeley 1995, p.12.

1997 Jerry Gorovoy and Pandora Tabatabai Asbahi, *Louise Bourgeois: Pink Days and Blue Days*, exh. cat., Fondazione Prada, Milan

1998 Marie-Laure Bernadac and Hans-Ulrich Obrist (eds.), *Louise Bourgeois: Deconstruction of the Father, Reconstruction of the Father. Writings and Interviews 1923–1997*, Cambridge, Mass. and London 1998

1999 *Louise Bourgeois Special Issue, Oxford Art Journal*, vol.22, no.2
Jerry Gorovoy and Danielle Tilkin, *Louise Bourgeois: Memory and Architecture*, exh. cat., Museo Nacional de Arte Reina Sofia, Madrid
Rosalind Krauss, 'Louise Bourgeois, Portrait of the Artist as a Fillette', in Krauss, *Bachelors*, Cambridge, Mass.

2000 Marie-Laure Barnadac and Elisabeth Bronfen, *Louise Bourgeois: The Insomnia Drawings*, Zurich, Berlin, New York
Frances Morris, *Louise Bourgeois* (The Unilever Series), exh. cat., Tate Modern, London

2001 Mieke Bal, *Louise Bourgeois' Spider: The Architecture of Art-Writing*, Chicago

2002 Josef Helfenstein, *Louise Bourgeois: The Early Work*, exh. cat., Krannert Art Museum, University of Illinois

2003 Frances Morris, *Louise Bourgeois*, exh. cat., The Irish Museum of Modern Art, Dublin, in collaboration with August, London

2003 Robert Storr at al., *Louise Bourgeois*, London

2005 Mignon Nixon, *Fantastic Reality: Louise Bourgeois and a Story of Modern Art*, Cambridge, Mass.

2006 Marie-Laure Bernadac, *Louise Bourgeois*, Paris

2008 Frances Morris (ed.), *Louise Bourgeois*, exh. cat., Tate Modern, London
Paul Nesbitt and Philip Larratt-Smith, *Louise Bourgeois: Nature Study*, exh. cat., Inverleith House, Edinburgh
Pawel Althamer, Louise Bourgeois, Rachel Harrison, Parkett, no.82, with essays by Tracey Emin, Robert Storr and Giselda Pollock
Per Capodimonte Louise Bourgeois: Introduction to an Exhibit, exh. cat., Museum of Capodimonte, Naples

2010 Germano Celant, *Louise Bourgeois: The Fabric Works*, exh. cat., Fondazione Vedova, Venice
Udo Kittelman (ed.), *Hans Bellmer / Louise Bourgeois: Double Sexus*, exh. cat., Sammlung Scharf-Gerstenberg, Nationalgalerie, Berlin
Philip Larratt-Smith, *Louise Bourgeois: Les Fleurs*, exh. cat., Kukje Gallery Seoul

Copyright credits

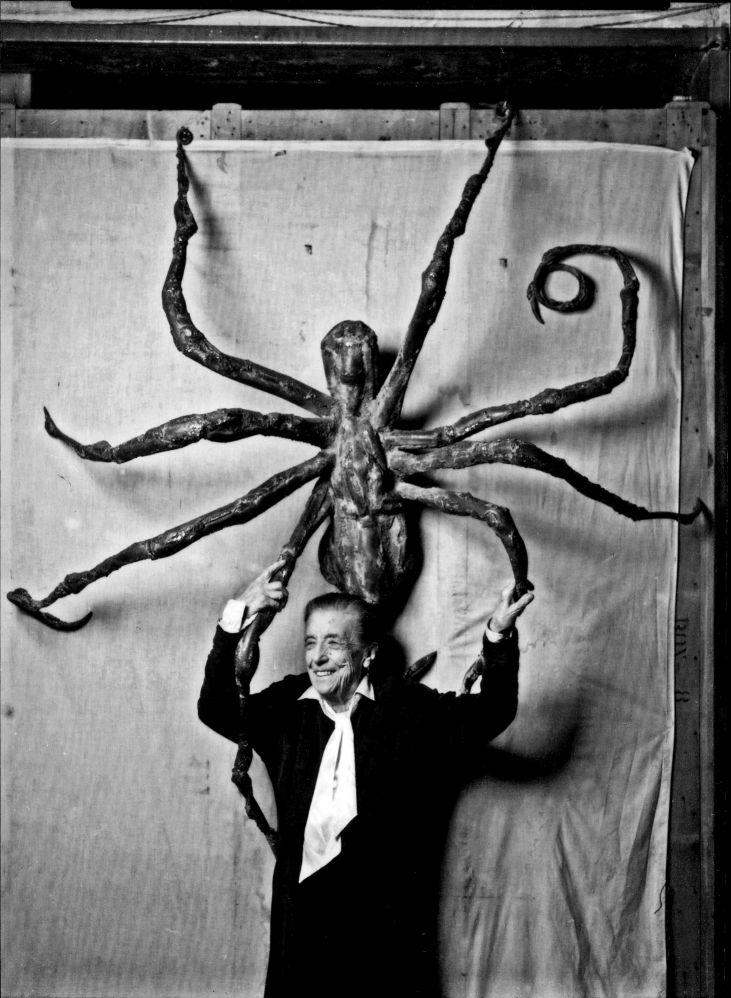